The Soul, Lover of God

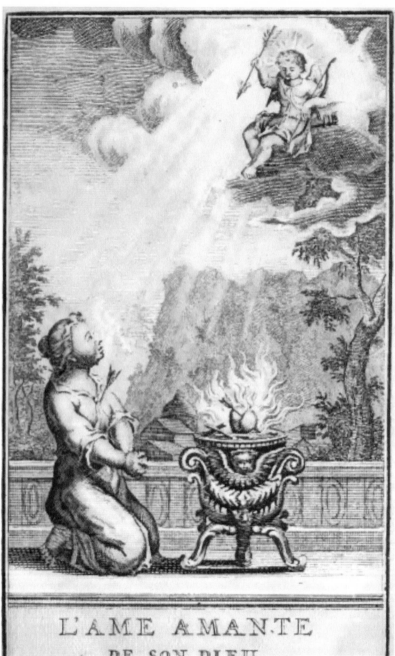

L'AME AMANTE

DE SON DIEU.

J. Goeree fec.

The Soul, Lover of God

Emblems by Madame Guyon
and Herman Hugo
The Theology of Emblems by Pierre Poiret
Translation by Nancy Carol James

To Ellen
with Kind regards

Nancy Carol James

UNIVERSITY PRESS OF AMERICA,® INC.
Lanham • Boulder • New York • Toronto • Plymouth, UK

University Press of America,® Inc.
4501 Forbes Boulevard
Suite 200
Lanham, Maryland 20706
UPA Acquisitions Department (301) 459-3366

10 Thornbury Road
Plymouth PL6 7PP
United Kingdom

Library of Congress Control Number: 2013958283
ISBN: 978-0-7618-6337-3 (clothbound : alk. paper)
eISBN: 978-0-7618-6338-0

Dedicated to

Robert Paul Scharlemann

1929-2013

Commonwealth Professor of Religious Studies

University of Virginia

For his brilliant understanding of religious symbols

Contents

Preface

When I first saw this emblem book in Paris in 1996, the unusual engravings and the passionate poems attracted me, yet many profound questions immediately posed themselves about this and they took time both to understand and to answer. After pondering this emblem book with its unusual illustrations and poetry, I realized that the emblems present themselves as symbolically-rich enigmas and puzzles that hint at traces of divine meaning while showing the potential for spiritual development. Fulfilling the intention of the author Madame de La Mothe Guyon, *The Soul, Lover of God* presents rich and fulfilling images revealing the metamorphosis of the human soul.

Yet when reading this book many questions suggest themselves to us, including the basic one: what is an emblem book? These books involve the creation of a new and symbolic meaning through the combination of an illustration with a text. The union of one engraved illustration with a corresponding text creates one emblem, and this first volume of *The Soul, Lover of God* contains 45 emblems. These books were extraordinarily popular in the 16th through 18th centuries but only in recent years has scholarship actively researched them. Some emblem books showed concern with the world and human love, while *The Soul, Lover of God* consists mainly of spiritual interests. Some of the most popular emblem books were John Bunyan's *The Pilgrim's Progress* and Herman Hugo's *Pia Desideria*.

The next occurring question concerns the identity of the author of poems Madame Guyon and the creator of illustrations Herman Hugo in this particular emblem book, *The Soul, Lover of God*. These two authors never met and in fact lived in different times and countries. Madame Jeanne de La Mothe Guyon (1648-1717) wrote many books on spiritual themes as well as being an avid poet. With her life as an unhappy teenage bride, a young mother knowing the deaths of two of her five children, and finally an incarcerated

widow judged by a long church inquisition, Guyon knew the depths of human sorrow. Yet even as she suffered through nearly ten years of imprisonment, she remained a faithful believer and spiritual director to many, as well as an author capturing her thoughts in eloquent words. A popular author in her own lifetime, her books and writings still attract many readers from around the globe. (For more information about Madame Guyon and her theology, see *The Complete Madame Guyon*, Paraclete Press, 2011.)

The Jesuit priest Herman Hugo (1588-1629) was a fascinating humanist Renaissance man as well as Catholic priest, who wrote several books. Hugo served as Spanish General Ambrogio Spinola's spiritual director and the head chaplain of his army. While caring for sick soldiers, Hugo became infected with the plague and died. His most famous book, *Pia Desideria*, included the engraved illustrations that are used in this book.

The questions continue. How did Hugo's illustrations and Guyon's poetry become connected? The famous Madame Guyon read Father Hugo's *Pia Desideria*, felt inspired by his emblem book, and wrote one poem for each of his engraved illustrations. She deleted all of Hugo's own texts but kept his scriptural reference with the illustrations. The union of Guyon's poems and Hugo's illustrations created the 45 emblems in this book.

In the early 18th century Dutch theologian Pierre Poiret decided to publish *The Soul, Lover of God*, along with many of Guyon's other books. A mystic in his own right, Poiret included an extended introduction in this book about the theology of emblems and art in the spiritually-aware life. Using many examples from spiritual history, Poiret says that God takes a visible and literal object and then places an immediate spiritual meaning upon it which may communicate a divine purpose. After his quality publication in 1717, this engaging and refreshing book became popular both in Europe and the New World and new editions were released in 1790 and 1791.

After translating and pondering many writings of Madame Guyon, I understand this volume as her mature thoughts about the union of the soul with God. Her fresh and engaging imagery is a joy to understand and to present in this first English translation.

This volume of *The Soul, Lover of God* will be translated as the original book was without additional commentary and footnotes. This book presents the Hugo engravings. The second half of the original book included 60 engravings from the artist Otto van Veen (also known as D'Othon Vaenius) and I have decided to publish these in a second volume. This decision is based on the fact that the original book ran about 425 pages and the length of this book deserves two volumes. Much scholarship waits to be done on *The Soul, Lover of God* but this volume will be the first step in introducing this fascinating work to English readers.

Nancy Carol James, PhD
November 11, 2013

Acknowledgments

This book would not be possible without the help of many. For the original I have used the 1717 *Ame Amante de son Dieu, representée dans les emblems de Hermannus Hugo sur ses pieux desirs* from the National Gallery of Art research library in Washington DC.

I want to thank Dr. Carlos Eire, the T. Lawrason Riggs Professor of History & Religious Studies at Yale University, for his assistance in researching and understanding Madame Guyon's theology, as well as directing my University of Virginia PhD dissertation, *The Apophatic Mysticism of Madame Guyon*. I appreciate Dr. Peter Phan of Georgetown University who provided a needed theological perspective on this work. I also want to express my gratitude to Dr. Sharon Voros from the Naval Academy, for her discussions about the theology of Madame Guyon. I also thank Dr. Bob Crewdson, an Episcopal priest and author, who helped interpret these spiritual emblems.

I wish to thank research librarian Jennifer A. Durand for her editorial assistance in both the introduction and poems. I also express my gratitude to Dr. Jane M. El-Yacoubi for her assistance understanding the detailed process of engraving. Hayden Bryan helped edit this book in its early stage. John Duncan provided a needed philosophical perspective on these symbolic emblems. Nancy Warren Merritt added expertise from perspective of art history as I developed this book. John Buydos helped research this project at the Library of Congress. The Rev. Dr. Elly Sparks Brown has provided lively and learned conversation about these theological ideas. Roger James Nebel gave needed computer expertise for the emblems, as well as sharing his ideas about spiritual development. Hannah and Melora James enthusiastically supported the writing and translating of this emblem book.

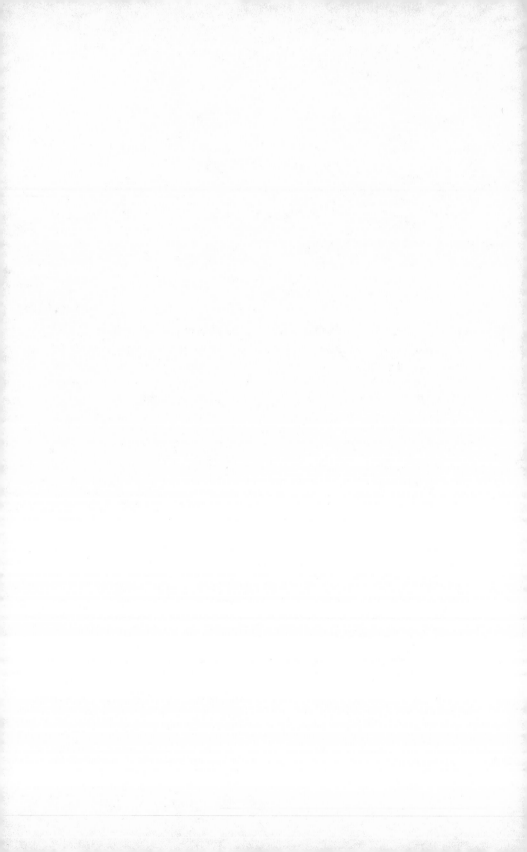

Introduction

Written by Madame Jeanne de La Mothe Guyon, *The Soul, Lover of God*
combines her poetry with Herman Hugo's illustrations from *Pia Desideria*.
Guyon, a controversial author and theologian, spent almost ten years incar-
cerated by King Louis XIV for charges of heresy and witchcraft before her
legal vindication, and, according to her own words, this is the book she chose
to carry into her years of incarceration in the Bastille. In *The Soul, Lover of
God*, Guyon declares openly her theology concerning spiritual development,
and writes an open conversation with God as she seeks spiritual union with
the divine.

Many similarities exist between Guyon and the Jesuit thinker Hugo. Both
appreciated literature, and wrote at length about it, extolling its spiritual
benefits. Both believed that they were orthodox thinkers, although questions
were raised about both of them. Both were on the cutting edge of accepting
Renaissance thinking and Counter-Reformation spirituality. Also, both of
them continue to grow in influence in our post-modern era, while scholarship
understands more and more about this unusual art form with its advent and
growth in both popularity and influence.

A member of the Society of Jesus, Hugo developed his emblem book dur-
ing the time of great change in the 16th century. Scholar G. Richard Dimler
in his *Studies in the Jesuit Emblem* says that the influence of Renaissance
humanism on the founder, St. Ignatius, and the newly-organized Society of
Jesus helped encouraged this genre of the Jesuit form of the emblem book.
As Ignatius studied classical rhetoric in Paris with its emphasis on how to
influence the human heart, the hope grew that "through the emblem book the
reader will come to know and converse with God" (171). Dimler describes
the "peculiar Jesuit desire to use humanistic rhetoric, the symbol, the device,
the enigma and the emblem in a striking and innovative way to proclaim the

Jesuit message. The emblem was particularly suited for the purpose since it combined word and image into a new synthesis" (71).

With the additional support of the *Spiritual Exercises* written by St. Ignatius, these emblems encourage the use of human senses and imagination in the search for God. For example, Hugo's illustrations, created by the engraver Bolswert in his workshop in Antwerp, employ natural symbols such as sun, storms, stars, birds, and deer, as well as symbols of telescopes, compasses, sundials, and mirrors that show the Jesuit acceptance of science and technology. Each illustration with its conglomeration of symbols has a scriptural reference at the bottom, with the majority derived from the Biblical wisdom books that intrigued this era: the Psalms, the Song of Songs, and Job. Each emblem brings its own satisfaction as the reader engages with it as a puzzle or enigma that needs solving by the reader's participation in the conversation with the ultimate.

Hugo's illustrations speak openly about human feelings and struggles as a human soul moves into relationship with God. The illustrations use two figures to reveal the growing relationship between the soul and God by body language and setting. The figure of a young girl signifies the soul and is called by the Latin name for soul, Anima. According to G. Richard Dimler, the second figure is a young boy called Divine Love or Christus; a different scholar, Hester M. Black, referring to the same figure, calls him "Christ as the Winged Boy"(6). The soul and God learn of each other's existence, and then the soul becomes a growing, changing force as vanity departs and love enters her heart.

Guyon resonated with Hugo's illustrations. Because of the serious challenges she faced in life, she possessed a natural affinity with emblems that depicted open conflict and suffering, yet she also recognized tender moments of realized love. Her poems read like the Psalms in the Bible: heart-felt cries of sadness, impassioned praise to God, sad desolation over the apparent absence of God, worries about evil, and concern over the state of his or her own heart. A prolific writer, Guyon describes in these poems her passionately-held theology that she called annihilation. She writes that in annihilation, described as the lengthy operation of God, the Holy Spirit tears down the interior of the naturally-built person with its accompanying worldly life and teaches him or her to have the pure love of God inside. To introduce this pure love requires an open space within that only the annihilating and destroying forces of the Spirit can create. Hugo's images provided good support for Guyon's controversial ideas of annihilation. In Emblem IV, Divine Love chases Anima around bearing a stick-like weapon, seemingly threatening to hit her. In Emblem XIX, Divine Love wears a terrifying mask and Anima shrinks back in fear. In addition, Hugo interchanges illustrations of intimate and tender love

between Anima and Divine Love, such as in Emblem XXIV, with consequent ones of terror and fear, with an example of the skeleton in Emblem XXXVIII. Guyon understood the process of divine annihilation developed in this pattern, with times of sweetness followed by ones of desolation.

For Guyon, the stakes were very high whether the person chose to allow or resist this oft-perplexing operation of God of annihilation, because the loss of the human soul was the greatest possible disaster in human life. The danger of perdition (derived from the Latin perdere to throw away, destroy, and loss) describes the loss of the soul, which is the ultimate fear in *The Soul, Lover of God*. Throughout these poems, Guyon states that the soul languishes, becoming weak and failing, unless the soul seeks with vigor for the divine. The greatest terror would be the loss of the soul and, as shown both in the poems and engravings, many souls perish during their journey in life.

Guyon designed *The Soul, Lover of God* as a conversation between the Lord and the Soul in which the reader receives an invitation to join in the dialogue, in the same tradition of the spiritual conversation between the Lord and the soul in the fourteenth century *The Dialogue of Catherine of Siena*. Some of Guyon's poems are divided into sections in which the Lord speaks and the Soul answers, though in most the Soul addresses the Lord in honest and passionate words. In a frequent theme, the Soul asks to become one with the Lord and for them together to have unified hearts.

In *The Soul, Lover of God*, Guyon took the three-part division of Hugo's *Pia Desideria* and applied to it what she called the three sighs of spiritual communication with God. She used the biblical image of the sigh, which is a symbol combining many literal factors: a cloud of meaning, emotions of fear or even contentment, a breath of life, and a form of communication beyond the use of literal words. She states that the divine purpose of these three sighs is the final consolation of the human heart. Guyon says that in the first sigh, the person sees his or her lack of love and kindness, and indeed, the offenses caused by these to the Lord. The person cries out to God, but the cries are grounded in self-interest, and out of concern about what will happen to his or her soul for eternity, and what losses the person will suffer in this lifetime. In this sigh, the suffering and pain of the spiritual journey seem too extreme for the person to undertake. The Lord listens and guides out of distress, but because the corrupted motivation of this first sigh is to preserve the self, the sigh returns to the person and does not stay with the Lord. The first sigh includes emblems I-XV.

In the second sigh, the person mixes self-love and divine love in the heart as he or she sees the beauty and awe of the Lord and begins to seek the divine in increasingly intense ways. Divine Love appears desirable and the soul yearns with passion and love to find union with Divine Love. Yet elements of

self-concern remain a driving force in the human heart and because of this, Divine Love is still elusive and remains a moving target. The person wants to live and die for the Lord, but because of the vision of this long and difficult journey, the person develops a desire to die and leave this life. As the person continues the search, his or her love becomes increasingly purified and self-interest suffers a slow and painful death. Guyon says that pain is a major part of the second sigh as the soul loves and discovers increasing fulfillment as the person takes his or her eyes off of the self and turns them to God alone. The second sigh has a potent power because of the vision of God remaining before the eyes, and because of this, the sigh reaches the heart of the Lord and a superficial union is found between the two that Guyon calls the union of the powers and not of essence. The second sigh includes emblems XVI-XXX.

In the third sigh, the soul has left the region of the self and is finding a growing and satisfying union with the Lord, called a union of the essences. The Soul and the Lord have journeyed and loved together, and hence the Soul understands the depth of love the Lord has for her. In this understanding and contemplation, the Soul loses frenetic and panicked qualities and now loves the Lord without fear of betrayal and loss. Guyon calls this the abandoned soul that has yielded all to the Lord and now through the annihilation of all selfishness, knows a union between her Soul and the Lord, even as the earthly life continues. No longer a part of the world, the Soul, having passed into the divine, remains on the earth but enjoys the peace and happiness of the Lord within. In Emblem XLIV the soul sits happily in a garden while looking directly at Divine Love and the heavenly host. This third sigh unites with the Lord, never to return to the soul again. The third sigh includes XXXI-XLV.

Detailed Description of the Emblems

Nancy Carol James

TITLE PAGE ILLUSTRATION

From the heavens, Divine Love aims an arrow at Anima's heart. Looking up at him, she kneels with her heart pierced by an arrow, while in front of her is a heart with an arrow in over a burning fire.

DEDICATION TO JESUS:
ILLUSTRATION WITH THREE ARROWS

Anima exposes the arrow in her heart that points to the Divine Eye and Ears of the Lord. While her heart is speaking to God, she rests with her bow on her lap. The three arrows reflect the three sighs from the heart which is the structure of Guyon's book: the three sighs of the heart, each with an increasing purity, reach the listening ear and watching eye of Divine Love. Anima has taken off a mask and put it in the bushes to on her right side.

"O Lord, all my longing is known to you; my sighing is not hidden from you" (Psalm 38:9).

BOOK I: THE FIRST SIGH

EMBLEM I

Anima reaches out to Divine Love who glows with light from a lamp he holds and has a pointed index finger. Many stars scattered across the midnight sky

like the Milky Way glow in the background. The night in the emblem shows a literal night; Guyon compares this night to the night of divine love which Anima will enter.

"My soul yearns for you in the night" (Isaiah 26:9).

EMBLEM II

Anima is decorated with trinkets from head to foot, looking silly and foolish, something like a court jester. She carries a tiny flag that seems too small for the person while carrying a basket with a cat peering out and the reins of a tiny horse. Divine Love covers his face and has his index finger pointing up.

"O God, you know my folly; the wrongs I have done are not hidden from you" (Psalm 69:5).

EMBLEM III

Ornate bed curtains surround a bed where Anima lies sick. Divine Love, full of concern, comforts her while taking her pulse and checking for fever. A sphere of perfect light surrounds the head of Divine Love. Ornate lines and decorations on the curtains and bed provide a sense of order and the care of God. Ropes holding up the canopied bed seem strong and trustworthy.

"Be gracious to me, O Lord, for I am languishing; O Lord, heal me, for my bones are shaking with terror" (Psalm 6:2).

EMBLEM IV

At a mill, Divine Love and Anima encounter one another. Divine Love looks kind yet has a raised stick encouraging her movement. In a defensive posture, Anima is enchained in ropes and goes in circular on mill grinding wheat. The illustration builds on the symbol of the operations of God in the soul like the grinding of the kernels of wheat.

"Relieve the troubles of my heart, and bring me out of my distress" (Psalm 25:17).

EMBLEM V

Anima now sits at the feet of Divine Love with her trusting hands, palms upward, reaching for him, in this depiction of God as the potter and the person as the clay from Jeremiah 18:1-6. Divine Love sweetly re-shapes Anima while she yields to him. She blows dust from her fingers as she experiences transformation. Divine Love's potent actions have relieved the soul from her distress caused by many factors: vanity, fever, fear, and chains.

"Remember that thou fashioned me like clay; and will you turn me to dust again" (Job 10: 9)?

EMBLEM VI

Divine Love manifests power through his worn symbols of armor, headdress, and two swords while Anima kneels and reaches toward him with vulnerable hands; at Divine Love's feet rests Anima's unused swords. In contradistinction to the armor, Divine Love's cheerful face and glancing eyes appear gentle. This illustration shows the Christian experience of the divine test where the soul must have faith and trust in the midst of apparent danger. To become close to Divine Love, Anima must lay aside all weapons and pass through by the sigh of love emerging from within the heart.

"If I sin, what do I do to you, you watcher of humanity? Why have you made me your target" (Job 7:20)?

EMBLEM VII

A much stronger character now, Anima tries to pull Divine Love's hand away from covering his face. In the foreground the bushes reflect her active energy. In the background, dark clouds open up and reveal a solar eclipse, a symbol both of exotic beauty and grave danger. The illustration compares the moon hiding the sun to the hand hiding the face of Divine Love.

"Why do you hide your face, and count me as your enemy" (Job 13:24)?

EMBLEM VIII

Her body crumpled on the ground, Anima weeps with her hands clasped in prayer and as she cries, her tears transform her into a fountain with hands stretched overhead pouring water into a container. Dark clouds in the sky hide most of the light yet through a small opening Divine Love pours out a direct stream of renewing water upon Anima's head. In the background an evil goat-like face spews forth water that looks like it tries to drown Anima. Her tears show her yielding heart.

"O that my head were a spring of water, and my eyes a fountain of tears, so that I might weep day and night" (Jeremiah 9:1)!

EMBLEM IX

Caught in a trap, Anima cries out for help. A skeleton holds the end of the net that contains Anima. A huge spider web with a black spider looms overhead while in the background demons carrying torches with flames chase people. The tree holds a log precariously teetering over Anima and she raises her hand up as if in a vain attempt to try to defend herself against the falling limb.

"The cords of death encompassed me; the torrents of perdition assailed me" (Psalm 18:4).

EMBLEM X

Divine Love sits in front of an open book with a quill pen in his right hand and his left index finger pointing up. Lady Justice, holding judgment scales in her left hand and a two-edged sword in her right, presents humble Anima to Divine Love. Anima hangs her head while waiting for judgment. The Ten Commandments on tablets hang above the head of Divine Love.

"Do not enter into judgment with your servant, for no one living is righteous before you" (Psalm 143:2).

EMBLEM XI

Lost in the waves of a raging tempest, Anima looks like she could be on the verge of going under and drowning, and with outstretched hands she desper-

ately seeks help. In the background lightning strikes in a big thunderstorm where a broken ship heads under to destruction; a looming, frightening looking tree hovers in the foreground. Firmly grounded on a rock, Divine Love reaches out his sturdy hand to Anima, although their hands have not reached the other yet.

"Do not let the flood sweep over me, or the deep swallow me up" (Psalm 69:15).

EMBLEM XII

An avenging Divine Love throws arrows and lightning at Anima who hides in a cleft in the rock and tries to defend herself. With its openness to the outside elements, the cleft provides little protection from the arrows. In imitation of the action of throwing, the pattern in the background looks like lightning and thunderbolts. Leaves grow on the rocks. The illustration symbolizes the wrath and justice of God.

"O that you would hide me in Sheol, that you would conceal me until your wrath is past" (Job 14:13)!

EMBLEM XIII

The weeping Soul appears under duress and points to a sundial lying on a table, with tiles that signify the passing of time. Tall and stately trees line the side of the illustration and an elegant mansion behind closed doors rests alluringly in the background.

"Are not the days of my life few? Let me alone, that I may find a little comfort" (Job 10:20).

EMBLEM XIV

An alert Anima looks through a telescope and sees a two-tiered vision: on the bottom a skeleton holds swords and stands in front of a raging fire while above Divine Love reigns surrounded by two angels and a spherical heavenly host. Divine Love's right hand is raised in a blessing.

"If they were wise, they would understand this; they would discern what the end would be" (Deuteronomy 32:29).

EMBLEM XV

Anima sighs and it appears as a cloud leaving her head. She is immobile with her hands at her side; on her right is seen the sun and on her left the moon. An angel symbolizing death reigns in the sky like a grim reaper with a bow and an hour glass on the angel's head. Connecting her with God, Anima's sigh to God releases her from the power of the sun and moon.

"For my life is spent with sorrow, and my years with sighing" (Psalm 31:10).

BOOK II: THE SECOND SIGH

EMBLEM XVI

Divine Love holds the tablets of the law, which look like a mirror, up to the Soul. With her right hand the Soul reaches out for the law and with her left hand pushes away the liberty cap that signifies the potential for disobedience to God's will. In the background horses frolic and play which also suggests the temptation to rebel against the demands of the Law.

"My soul is consumed with longing for your ordinances at all times" (Psalm 119:20).

EMBLEM XVII

The Soul walks on a dangerous labyrinth with a scepter in her left hand and a guide rope with her right hand. At the top of a high tower placed on distant mountains, Divine Love holds and pulls the other end of the guide rope. There is a narrow, winding path on the labyrinth yet no obvious way to reach Divine Love at the top of the tower. Several other people have fallen off and with outstretched arms cry for help, yet a blind man walks confidently along as he follows the direction of his small dog. The labyrinth looks like the top of a fort and in the background there rests a peaceful sea.

"O that my ways may be steadfast in keeping your statutes" (Psalm 119:5)!

EMBLEM XVIII

Reaching toward Divine Love, Anima rests on a walker that helps her move in the courtyard of grand and elegant buildings. Divine Love's hands are held

high as if in an intimate revelation; his intent eyes seem to be instructing her. The bare feet of both Divine Love and Anima signify active motion. Statues of noble people grace the top of the buildings with a visible cross seen in one window.

"My steps have held fast to your paths; my feet have not slipped" (Psalm 17:5).

EMBLEM XIX

In the midst of an immense confrontation, Divine Love, wearing a frightening mask and with his right hand clasping living lightning, approaches Anima. In his left hand he brandishes a thorny club. Losing her balance, a startled and kneeling Anima shies away from the danger and the thunderbolts. In the background more lightning and thunder flame out from heaven yet from the dark heavens, a single star shines pacifically in the sky and casts a single ray of light.

"My flesh trembles for fear of you, and I am afraid of your judgments" (Psalm 119:120).

EMBLEM XX

Divine love puts his hands over the eyes of Anima and tries to shield her from the sight of Vanity pictured as an arrogant woman looking like a crowned queen in a fanciful costume. The bushy branches of the tree at the left hand side of the illustration form a pastiche of light and dark shadows.

"Turn my eyes from looking at vanities" (Psalm 119:37).

EMBLEM XXI

A kneeling Anima offers her heart to Divine Love who holds up the tablets of the law with a heart mirrored on each side. On a table in the back rests cosmetics and a mirror and light shines in the enormous mansions where this exchange of hearts takes place.

"May my heart be blameless in your statutes, so that I may not be put to shame" (Psalm 119:80).

EMBLEM XXII

Divine Love and the Anima go on a journey together holding hands and carrying pilgrim's staffs. Anima wears a pilgrim's hat and traveling clothes and cape. They stroll through a door that stands open and enter into a good and peaceful land, and begin traveling on a wide and secure road. The clouds seem to imply a heavenly presence.

"Come, my Beloved, let us go forth into the fields, and lodge in the villages" (Song of Songs 7:11).

EMBLEM XXIII

Divine Love runs away from Anima holding a flame torch and wearing a victor's wreath on his head. In his right hand he holds a guide rope that Anima holds the opposite end of in her left hand. The trees, flower beds, in the back and plants looks exotic yet gracious.

"Your anointing oils are fragrant. . . . Draw me after you, let us make haste" (Song of Songs 1:3-4).

EMBLEM XXIV

Anima holds and kisses Divine Love who is now like a baby with a cradle and a walker. Both share one halo and they intimately have their hands on each other's faces in the large, spacious room they share.

"O that you were like a brother to me, who nursed at my mother's breast! If I met you outside, I would kiss you, and no one would despise me" (Song of Songs 8:1).

EMBLEM XXV

Anima points with her right index finger to the empty and open marriage bed while showing a way to this inviting bed with the lighted candle held in her left hand. Instead of resting in the bed, Divine Love has his arms folded and lies upon a cross on the floor next to the bed. Once again, a guide rope joins Anima and Divine Love.

"Upon my bed at night I sought him whom my soul loves; I sought him, but found him not" (Song of Songs 3:1).

EMBLEM XXVI

In excitement Anima rises from the solitary bridal bed while gesturing with her left hand. She follows an unseen figure holding a flaming torch. Looking at Anima's action, a little dog jumps with excitement. Divine Love peers from behind the bed curtains. This seems like the beginning of an adventure.

"I will rise and go about in the city, in the streets, and in the squares; I will seek him whom my soul loves. I sought him, but I found him not" (Song of Songs 3:2).

EMBLEM XXVII

Anima and Divine Love share a close and long embrace with her hands gently resting on his back. In the background is the outside of a castle with the guard on the tower talking to a woman below.

"Have you seen him whom my soul loves? Scarcely had I passed them, when I found him whom my soul loves. I held him and would not let him go" (Song of Songs 3:3-4).

EMBLEM XXVIII

Walking on a beach in the middle of a storm, Divine Love carries both Anima and a large ship's anchor on his back. Rain soaks the ocean, but not Anima and Divine Love, and shells on the beach appear like bones. Lightning strikes toward a capsized ship in the ocean that has left two people drowning. A lighthouse stands in the background.

"But for me it is good to be near God; I have made the Lord God my refuge, to tell of all your works" (Psalm 73:28).

EMBLEM XXIX

Divine Love, hands nailed in a cross configuration in a tree, hangs suspended while Anima sits below contemplating. The friendly scenery, including trees,

Detailed Description of the Emblems

flowers and fruit, supports the loving sacrifice and Anima's peaceful reception of it.

"With great delight I sat in his shadow, and his fruit was sweet to my taste" (Song of Songs 2:3).

EMBLEM XXX

Divine Love instructs Anima by holding a book open to her and gesturing with his raised hand while they sit on adjoining plots of land. Looking sad and yearning, Anima reaches for a mandolin with her left hand. The landscape looks strange and disjointed.

"How could we sing the Lord's song in a foreign land" (Psalm 137:4)?

BOOK III: THE THIRD SIGH

EMBLEM XXXI

Looking childlike, a reclining Anima has an arrow piercing her heart. She looks up at the daughters of Jerusalem with both hands gesturing with palms facing out. Anima is taking an oath with her right hand and appears filled with awe.

"I adjure you, O daughters of Jerusalem, if you find my beloved, tell him this: I am faint with love" (Song of Songs 5:8).

EMBLEM XXXII

Anima leans back and reposes surrounded by the daughters of Jerusalem. Their laps are full of ripe apples and a basket of fruit rests in front of them. Beautiful trees grace the background.

"Sustain me with raisins, refresh me with apples; for I am faint with love" (Song of Songs 2:5).

EMBLEM XXXIII

Anima and Divine Love hold hands and crown each other head's with flowering wreaths. Happily they sit together in flower beds with a three-tiered castle gracing the background.

"My beloved is mine and I am his; he pastures his flock among the lilies" (Song of Songs 2:16).

EMBLEM XXXIV

In her left hand Anima holds a compass while holding her right hand over her heart. Light shines out of the face of Divine Love and hits the compass, while he also holds his right hand over his heart. To the right of them, a giant, healthy sunflower reaches toward the shining sun.

"I am my beloved's and his desire is for me" (Song of Songs 7:10).

EMBLEM XXXV

Fire coming out of Divine Love's mouth reaches for the yielding soul's heart. In the background a tall lighthouse and a distant mountain landscape look inaccessible but beautiful. Waves gently lap at the feet of Anima and Divine Love.

"My soul failed me when my Beloved spoke" (Song of Songs 5:6).

EMBLEM XXXVI

Sitting comfortably on the Earth, Anima reaches out with her left hand to a perfect, heavenly sphere from which Divine Love looks out with open embracing arms. Stars adorn the heavens.

"Whom have I in heaven but you? And there is nothing on Earth that I desire other than you" (Psalm 73:25).

EMBLEM XXXVII

In the midst of dark and gloomy overhanging foliage, Anima points to her exile below in the desolate valley. The pilgrim's hat and walking stick lay beside Anima.

"Woe is me, that my sojourning is prolonged! I have dwelt with the inhabitants of Cedar: my soul has been long a sojourner" (Psalm 119:5-6).

EMBLEM XXXVIII

Wringing her hands together, Anima sits inside a skeleton. Encapsulated inside the dry bones, she looks constrained and seems to be pondering how to escape. The skeleton has his elbow leaning on a dark rock and his skull leans on his bony fingers. In the back a skeleton of a leaf-less tree accentuates the desolation.

"Wretched man that I am! Who will rescue me from the body of this death" (Romans 7:24)?

EMBLEM XXXIX

Chained to a heavy ball, Anima has sprouted wings as she happily reaches to Divine Love who with outstretched hands beckons from heaven. Behind and below Anima, a child points to his bird on a string that mirrors her soul chained to the earth.

"I am hard pressed between the two; my desire is to depart and be with Christ, for that is far better" (Philippians 1:23).

EMBLEM XL

An energetic Divine Love unlocks the cage and responds to Anima who is reaching out to him. In the background a bird also freed from its cage flies toward heaven.

"Bring me out of prison, so that I may give thanks to your name" (Psalm 142:9).

EMBLEM XLI

Anima rides on the back of a deer who springs directly toward Divine Love standing in a flowing water fountain. The freed Anima, now open and loving, raises her hands mirroring Divine Love's raised hands.

"As a deer longs for flowing streams, so my soul longs for you, O God" (Psalm 42:1).

EMBLEM XLII

In an unfinished room with open boards overhead, Anima stands before a drawn curtain, holding out imploring hands, but Divine Love with his left hand holds the curtain shut between them. Divine Love's finger is resting on his lips, a gesture showing interior reflection, and waits. The curtains hide Divine Love's face from Anima.

"When shall I come and behold the face of God" (Psalm 42:2)?

EMBLEM XLIII

Now Anima's arms have become long and powerful wings and, pushing away from the ground, she begins to fly away over the ocean. Already flying high in the sky, Divine Love points above to heaven where the light comes from. A bird with wings appearing like Anima's, looks at her attempting flight.

"And I say, 'O that I had wings like a dove! I would fly away and be at rest'" (Psalm 55:6).

EMBLEM XLIV

A large and generous outpouring of light from heaven shines on the receptive Anima. Bathed in light, she sits in a garden with trees with hands raised up and looks directly at Divine Love sitting on the tabernacle surrounded by the heavenly host.

"How lovely is your dwelling place, O Lord of Hosts! My soul longs, indeed it faints for the courts of the Lord" (Psalm 84:1-2).

EMBLEM XLV

In a pastoral country setting, Anima sits on the ground looking toward Divine Love, who beginning to run away, turns to speak to Anima and with his hands points toward the mountain. She receives the message with joy. A jumping deer already leaps up a mountain in the background.

"Make haste, my beloved, and be like a gazelle or a young stag upon the mountains of Spices" (Song of Songs 8:14).

Translator's Notes

This first volume of *The Soul, Lover of God* presents the first published English translation of Madame Guyon's poems with Father Herman Hugo's engravings and Pierre Poiret's preface. A second volume is planned for Guyon's poetry with the illustrations of Otto van Veen, an artist also known by the Latin name of D'Othon Vaenius.

In this volume of *The Soul, Lover of God* the accompanying Hugo engraved emblem is placed before Guyon's poem. Her interpretation of the symbolic engravings will be allowed to stand alone without additional commentary or footnotes. The original italics have been retained in this translation.

All citations in the Pierre Poiret introduction are from the original source. The translations of the scriptures in the "Introduction" are taken from the New Revised Standard Version Bible.

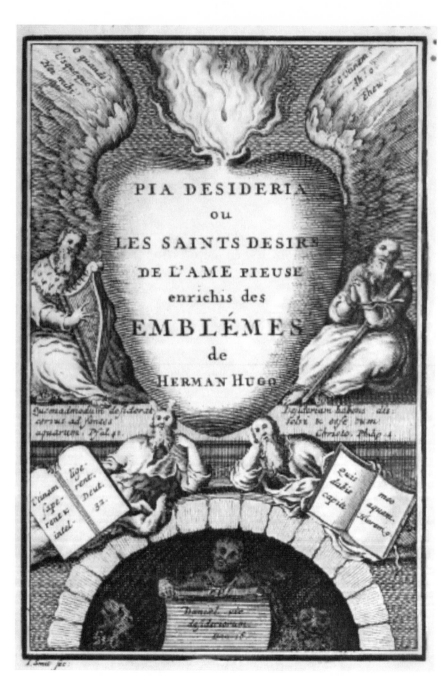

PIA DESIDERIA
ou
LES SAINTS DESIRS
DE L'AME PIEUSE
enrichis des
EMBLÉMES
de
HERMAN HUGO

The Theology of Emblems

Preface to the Emblems of
Father Hugo and Madame Guyon

Pierre Poiret (1646-1719)

SUMMARY

1-4 The use of external things, visible and emblematic, to present things invisible and interior, is easy, pleasant and proportioned to the capacity for everyone. Several examples are offered of this use.

5-7 Emblems that act on the heart are preferable to those that awaken the mind; the way of the heart is much better than speculation, according to the very Word of God.

8-9 The explanation the individual characteristics of Hugo and Vaenius along with their subject and their previous editions.

10-12 Concerning this new edition with its new verses and insertions and character about the pure love of God. Excellence of this path of Love recommended by several examples of scripture and the last centuries. Provisions required to benefit from this book.

CONTENTS

1. God is pure spirit and the principal part of the human being is also Spirit. The essential part of divine worship, the adoration of God, asks this of us: that worship must be in the spirit and in the interior. Jesus Christ himself assures us of this in John 4:24 "God is spirit, and those who worship him must worship in spirit and truth."

Nevertheless, as humans because of sin became all exterior, they decayed into the sensible and visible and forgot the invisible and the spiritual. It pleased God to raise humanity from their Fall, to condescend to their gross disposition by using the same visible things apparent to their senses to bring

them to the divine interior where they have been created. All that our eyes discover in the works of creation can be employed for this beneficial purpose in the same intention of God as seen in the assertion of Saint Paul: *"Ever since the creation of the world his invisible nature, namely, his eternal power and deity, has been clearly perceived in the things that have been made"* (Romans 1:20). If we do not praise and glorify God, we are guilty of inexcusable criminal negligence. The majority of the commandments in the Law of Moses about Jewish worship address the proper use of a variety of outward and visible things established by God to mark invisible and interior matters. How often also did Jesus Christ and his apostles use emblems and similitudes from natural situations such as practices of government, war, peace, contracts, friendship, love, marriage and others to elevate our spirits and our hearts to the consideration and love of spiritual things, of heaven, and of eternity? Examples of this abound in Holy Scripture.

2. This method of presenting subjects to spiritual minds from sensible and material objects fell on us from the goodness of God, and the condescension of God's wisdom to our weakness. There is no doubt that this beneficial use should be recommended, as easy, pleasant and proportionate to the capacity of all sorts of persons.

3. And indeed like children we can learn fruitfully with pleasure and entertainment, have holy thoughts about God, touching their duty toward the divine by putting before their eyes a few figures of several common things to which their heart and spirits naturally tend. Hence, it is easy to teach them how they should run toward God, the Creator of all things, and in particular their personal Creator and Redeemer.

For adults, the appearance of visible things may serve as an occasion for their conversion, when God uses these ways and prints adults with vivid and powerful impressions on their hearts which makes substantial changes, for even the rest of their lives. A simple idea occurs to them, causing them to become interior and restored in newness. We hear of a simple soldier who became the holiest of souls, and of whose letters were published recently (St. Lawrence of the Resurrection in *The Practice of the Presence of God*, pg. 57).

He saw a tree dry in winter and suddenly thought of God and this printed a knowledge so sublime in his soul which was still strong and deep after forty years. Following that experience, he used this practice at all times of seeing the invisible on the visible, and arrived at everything, first by passing from the creature to the Creator.

A great saint from recent centuries, St. Teresa of Avila, has also written about her conversion (St. Teresa in her *Autobiography*, Chapter IX) saying she saw a picture representing Jesus Christ covered with wounds and it had such an impact on her, that, she said:

I felt penetrated by the impression that felt the pain I had not recognized before of the suffering my Savior had endured for my salvation. My heart seemed to reach for him, and then all melting into tears and kneeling on the ground, I prayed the Divine Savior strengthen me once for all so I would never offend him. It appears to me, I had made only an evil return for his wounds, and I began to desire to put all my trust in God. I think that I told him this and that God heard my prayer, and I believe that this was very useful, and ever since that day I have been better than before.

4. Regarding the more advanced and perfect souls, they already see God everywhere and in all things. They read the Psalms of David in order to observe how the Holy Prophet himself felt, touched, revived, became delighted with admiration and joy, when he envisaged and regarded things visible and used these to rise to God's supreme grandeur, wisdom, and goodness in divine and spiritual matters.

The wisest of humans, his son Solomon, did the same when using human love and marriage to depict the mysteries in these Emblems for the grand and interior union of consummated spiritual souls and the Church sanctified with the celestial Bridegroom who appears in Solomon's divine Song of Songs.

5. These similar benefits are believed to be found in Spiritual Emblem books that bring salvation to all sorts of people and that, under the veil of various figures, reverently turn our souls to God. Through the Emblems, the Spirit implants certain ideas or considerations, or in other people, awakens in their heart a movement of affection to love, to seek a holy and perfect union, as well as eternal possession by God.

This method is incomparably preferred to simple speculation, but this is contrary to the opinion of the majority of educated people, who despise the way of the heart and persuade (though vainly) that through a dry spirit, used and exhausted by all its activities, and all the forces of reason and ideas in reasoning about divine things, they can better find God, more than by the way of exercising our heart in God's Divine Love.

6. Without looking at the experiences throughout time, that makes us understand how little fruit has been produced by the human mind through cold speculation, the testimony of God alone must suffice to decide this question. It is incontestable and certain that God has promised to us divine and healthy knowledge and a beatific union for us who seek the way of the heart and love: *"Those who love me will keep my word, and my Father will love them, and we will come to them and make our home with them"* (John 14:23). But we do not find that he makes a similar promise to those who claim to know the way through the strength of their spirit and their reasoning. To the contrary, he declares that he resolved to *"hide them"* (Matthew 11:25) and that they will not understand spiritually by the conceptions of natural man and animal

(I Corinthians 2:14). When Jesus wanted to prescribe to humanity what they must do in the world to please him and to be reunited one day at the source of all good, he did not tell them, "You know me, or you will achieve knowledge of me through all the efforts of your head, by the industry of your mind, and by the work of your attention to all your ideas of reason and its activity:" but instead Jesus said, *"You shall love the Lord your God with all your heart, and with all your soul, and with all your strength"* (Luke 10: 27). This is also the purpose and the substance of all Holy Scripture.

7. This is the same way and purpose that we recommend in the following Emblems. All the world is not capable of proceeding by the way of intellectual speculation; but everyone has a heart, a penchant to love, inclinations, movements and the lively affections, that aid actions. We can exercise these on good or bad objectives, temporal or eternal ones. It is up to us to choose between these two ways, each of which solicits our love to be on one side; Satan and the world are on the part of evil by a thousand, strong attractions, an infinite number of vain books, impious, impure profane images and paintings, shameful and diabolical: on the other side

God draws us to his good movements with a sacred and healthy way. Happy are those who make the good choice and who remain in the hand of the source of true happiness, the ways that God wills! We may surely look at these two ways in the scriptures.

8. We look first at the recent emblems of Father Herman Hugo, because he is the most methodical and his emblems regard particularly the Soul's beginning. This book has been well-known for a long time so it is superfluous to say that is has been reprinted at various times and places with explanation of these Emblems in all sorts of languages. It is divided into three parts;

The first, destined for beginners, contains *"the sighs of the penitent soul"*; the second, for the use of the advanced soul, represents *"the desires of soul who is becoming sanctified,"* and the third in its title and matter is meant for the most advanced, as *"the soul sighs for its lover."* Each of these parts contains fifteen emblems, each emblem in the original Latin, with its particular figure; then a passage of Holy Scripture marking in a few words the representation of the Emblem, then in the third place is followed in a large number Latin verses on the same subject; and finally many passages of the Holy Fathers and the Church Doctors, applicable to the material in question.

These works imprinted in various vernacular languages were not obliged to keep all this material but only that which was principal and essential; and for this reason they had chosen Emblems with their figures, which they imitate or counterfeit, some good and some bad. In the second place, they have each chosen and translated in his or her own language all the passages of Scripture, but, I have not found the translation of the Latin verses that were attached.

Everybody preferred the work of poets and some compose verses from his or her head (some more and others less) on the subject of each emblem. As far I have seen, all omitted passages from the Holy Fathers, whether they regarded them as only an accessory to the work, as they are in effect, or they had purposely made the book more convenient and portable. This last consideration, however, did not allow the joining together of the Emblems of Father Hugo and d'Othon Vaenius; since the volume grew too large even though they belong to the same subject, in which they deal with the noblest part, that of divine Love.

9. We know that this Flemish author d'Othon Vaenius, famous painter, who did this work, published in his youth moral Emblems of natural love. Some years later, Princess Infant Isabella, Duchess of Brabant (1566-1633), who had seen them, wished that he worked in the same manner on Divine Love; it was easy to discover and to see similar qualities and effects; he made the Emblems we see here, which he dedicated to the same Princess. He put each figure opposite each other with words of inscription, and a few sentences or scriptures or the Fathers, who had rapport with it. His friends added a few verses, some in Spanish and others in French and in Flemish. Here they appeared the first time, a few years before the Emblems in 1615 and of Father Hugo in 1624.

After publication in various other places, some imitated him quite well, as in the Paris edition in Landry: they retained also the sayings on the inscriptions, but without the passages of Scripture, and without the church fathers: and also the verse, in each set, like that of Father Hugo, some of its initial way, but very little: The Paris edition has only four small lines for each Emblem. This was arbitrary: we retain the same usage in the present edition.

10. In all the emblematic figures of Father Hugo and de Vaenius, we have imitated the more excellent originals of the best Editions from these two authors. Their beauty, sweetness, and passion makes a good effect, equal to the best of these published so far in this Edition. We have retained the passages of Holy Scripture that were on the Emblems of Father Hugo and the sayings in Latin words of Vaenius, translated into French on these pages with respect to the figures, and immediately before the new verses that express the meaning.

11. These truly divine and admirable verses on both the Emblems of Vaenius and on those of Father Hugo are responsible for this present edition. They are appreciated more when the reader seriously applies his or her very heart to them. I do not say this because the rapport of this simple poetry, with its charms and beauty, both very lively and touching. I say this because the material is all holy and spirit, truly divine and of heaven. Here it appears to us that the poet has surpassed often the intention and thoughts of our two Authors of most of their Emblems. It is clear that their

intention was to represent that ordinary and gradual progress of ordinary souls whose conversion was begun by fear of the judgments of God and continued by the desire for reward. With sorrow, joy, and hope, we approach God to receive his gifts, and we advance towards the perfection of degrees in degrees; a way that is certainly very good with salvation in faith: *"but,"* to explain with St. Paul when he prefers charity to hope and faith, *"there is a high and* much *more excellent way"* (I Corinthians 12:31.) It is the way where the predominant manner of Pure Love, when the sinning soul without stopping for a detailed review of its past flaws and their demerit, suddenly sees the incomparable love of God and throws himself headlong into his arms so that he has what he or she pleases, as did the penitent sinner of the Evangelist of which Jesus Christ says, *"Many sins were forgiven her because she loved much"* (Luke 7:47). St. Peter, who when raised from his fall by the same love and truth, spoke the truth of this word and love, *"Lord, you know all things, you know that I love you"* (John 21:17). Also, St. Paul was converted by providing and absolute love, that the door opens first by sacrifice to the will of God when Paul says, *"Lord, you know what I must do"* (Acts 9:6). Paul understands the fact that he must generously persevere with courage through the rest: *"Who will separate us from the love of Christ? . . For I am convinced that neither death, nor life, nor angels, nor principalities, nor present things, nor future things, nor violence, nor heights nor depths, nor any other creature, will be able to separate us from the love of God in Christ Jesus our Lord"* (Romans 8: 35, 38, 39). This was also the way of the great and incomparable Catherine of Genoa, whose life and writings coming from this noble subject and when suddenly converted by pure love, could only utter these words, *"O Lord! Is it possible that you called me from your goodness, and that you have made known to me in a moment all that language cannot express"* (*Life of St. Catherine*, Chapter 2)! We see this way again in the holy Religious of Bretagne, Jean de St. Samson, who was blind from infancy yet bore this in his noble career without flinching and has left a large number of treatises full of ardor and divine unction that he had all dictated by the same Love; the good Father Lawrence of the Resurrection, whose conversion we mentioned a little earlier; finally that of the admirable Armelle Nicolas, called, the good Nicolas, poor one of the profane and a servant, whose heart and spirit, actions and speech breathed out the pure love of God, who had tested her with the most wonderful operations of God, about which she had said,

O my Love and my All, who had ever thought to see my heart in the state it is now? O love, though you are always the same, you are still different in your operations, and you know well how to accommodate to our weakness! Where is time, O Divine Love, that you act in my heart as Conqueror and Victor, armed

with fire and flames, burning, blazing, and consuming all that is opposed to the divine will, penetrating with your darts and your arrows, in strength I know that every day I must die: and you never remain in repose until you have conquered and triumphed. Then after, O Divine love, you reign as a powerful and peaceful King; a very sweet and merciful Father; a very loving and generous Bridegroom, invested with graces and favors with the profusion that only you have, O Divine Love! And now you reign in me O God! Yes, my God, you are all in all, incomprehensible and inaccessible, you are in this poor heart, you guard it with strength, so that nothing can approach it more than YOU ALONE (*The Life of the Good Armelle, Volume 1, Chapter 26, Edited in Holland, 1704*).

12. There are similar operations of Divine Love, all noble and generous, all pure and disinterested, that look at God Alone: his truth and unique being, his motif, his purpose and his all, that gives the sublime explanations on the Emblems following the attached verses that are ardent effusions of an animated heart acting upon the most pure Love of God, and elevations almost constant to the same heart of God. If I may hazard my thoughts or conjectures concerning their Author, I should say, that if this is not the same person who published more recently *Volumes of Explications and Reflections on the Old and New Testament Regarding the Interior Life,* (by Madame Jeanne de La Mothe Guyon) it must be at least a gentle person with the same spirit and disposition of heart; because we see the same principles and element of pure love as in the excellent *Explications and Reflections on the Holy Scripture.* Nevertheless, we still have the same freedom to read and judge as we will and find appropriate. We know only that the author of these verses has two sets of poems on the Emblems of Vaenius that were separately placed at toward the end of the book, without regarding the first as the inferior: the only difficulty that we have found is giving a place to all the two sets of poems with the figures, because they are both strong.

13. In conclusion, we wish all that want to make a good use of this book, the disposition of the soul that is required for this effect. It is clearly depicted in the figure of an infant which marks, the soul that wants to enter and persevere in communication with God and his divine Love, must be endowed with the kind and childlike qualities of innocence, simplicity, purity, candor, benignity, docility, and flexibility to be led and governed by God like a small child, without reluctance, without presumption, without fierceness, without malice, without fraud, and without duplicity of heart. This is what is required of us by faith in the Word of God by the mouth of David, Solomon, Isaiah and the Prophets, the Apostles St. Peter, St. Paul, St. John, and finally Jesus Christ, who assures us that *"The Kingdom of God is for those who are like children; if we do not want to receive it as a child, we do not enter it"* (Mark 10: 14-15.). Then we will have true knowledge, because the Father made

known his Son and the mysteries of his Kingdom to *the simple and small* (Matthew 11:25), following the assertion of the Lord, who sends his grace to renew the Earth by his Spirit of innocence, simplicity and childlike and filial Love. Finally that the *Name of God*, according to the Prophecy of David in Psalm 8:2, who praised and *"glorified in all places by the mouth of small babes,"* they alone taste eternally the blessings of his divine will! May we be among them!

"My heart shall speak wisdom, and the meditation of my heart announces understanding. I will incline my ear to the parables and sing enigmas on my harp" (Psalm 49:3-4).

Prologue

Here are manifested three kinds of sighs
For having offended the Creator of the world:
The cruel heart displeases God;
To satisfy Divine Justice,
God imposes some agony and
We work to correct ourselves;
This is the first way to help us change.

God's unparalleled kindness
Moves with the final purpose of our heart's consolation,
When we cease our sinning,
God annihilates and swallows us;
God delights in our humility,
Fills the heart with love:
These are also other sighs coming from the one flame
More pure, and already our soul
Sighs only for love.
This second sigh shoots toward God, and does not rebound:
For the first sigh returned to ourselves
Only regarding ourselves:
Yet we fear for ourselves even God's smallest blows:
The pain and sorrow seem extreme to us
For we envisage the future with only self-interest,
Yet we fear the cessation of the divine:
The second sigh of the loving soul now
Rises directly to the Lord: Yes, I want to perish
To be lost in You is glorious,
She says, O God, let me die soon.
For this love is mixed with pain

We are saddened by our offence and
We desire your vengeance.
We do not want God to spare our heart:
Punish, punish, my sweet Lord, for
This ungrateful heart is still a traitor.

This comes after the sigh for love,
This third sigh is delightful!
For the soul no longer is capable of pain;
She lives in another home:
Now we do more than languish on earth,
We wish to pass into our God:
The activity of this beautiful fire
Brings us back to the divine sphere.

Little by little the sighs extinguish,
We can no more sigh,
We can no more desire,
It seems as if this fire is charming and contrary.
No, no, it carries us into tranquility
The fire is not subject to this world:
We cross through the earth and the wave
To be lost in the One.

Dedication to Jesus

The Desire

Lord, all my desire is exposed to your eyes, and my sighing is not hidden from you.

I sigh for you, O my only good!
The sigh interprets the faithful heart,
Although my tongue is speechless
The language of the heart always reaches you.

You who know the secret of my soul
Do not reject my sighs:
Expressed, they double my flame and
Soften my distress.

Sleepless eye that watches, loving wisdom
From which nothing is hidden,
You know the evil of which I am capable
Though I have broken my heart off from everything.

In this sacred desert I sigh without ceasing:
I acknowledge however well
That these sighs come from my weakness,
And yet point to this most perfect Lover.

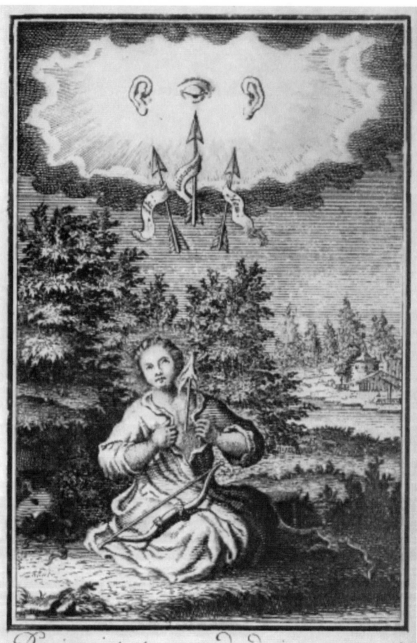

Domine, ante te omne desiderium meum, et gemitus meus à te non est absconditus. Psal. 37.

Book One

The First Sigh

I.

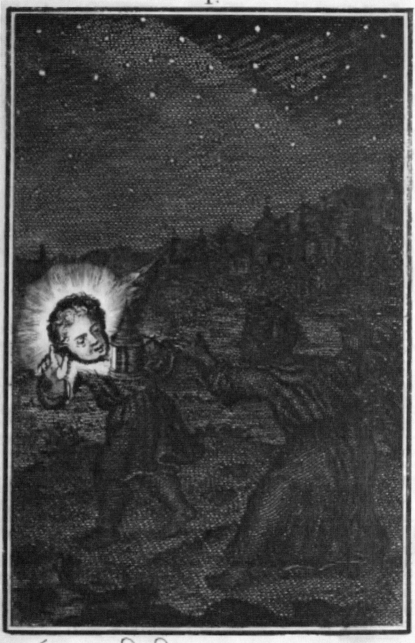

Anima mea desideravit te in nocte. *Isaia 26.*

EMBLEM I

My soul desires you during the night.

In two strong nights we search for the Bridegroom
One begins the journey:
By favor of this light
We leave the unsettling sins.

The soul sees well when she walks in darkness:
And this brings the dawn
Of celebrated conversions:
Even this weak light reveals the love.

There is another night, but this one all divine
It appears without a lamp or torch;
It is the purest love that illuminates itself,
And gives us a new state of being.

O dark faith, you are preferable
To a so-called clarity:
You make us all enjoy this unchangeable One
Who gives us happiness.

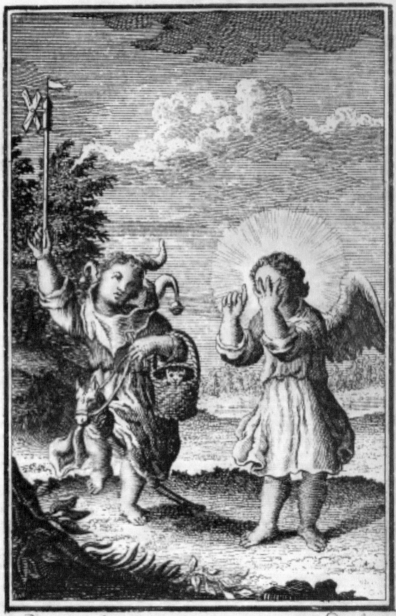

Deus tu scis insipientiam meam, et delicta mea à te non sunt absconaita. Psal. 68.

EMBLEM II

O God, you know my folly and my sins are not hidden from you.

I am unhappy when I am away from you,
And when I love such vain things!
I rank below in mad follies,
Walking among apparent certainties:
I lose my way every moment
In such vain amusements,
That I dare call wisdom:
Divine love, you call to me
You pull me out of my weakness,
You attract my heart and deign to speak to me:

Ah, I listen to this charming voice
Who speaks at the bottom of my soul;
I had followed my disgraceful choice
Yet I now dare to hide in your sweet flame:
I am horrified within
Over my folly:
I regret this! See my repentance!
It is you, divine Love, who changes my life,
You alone can transform me.

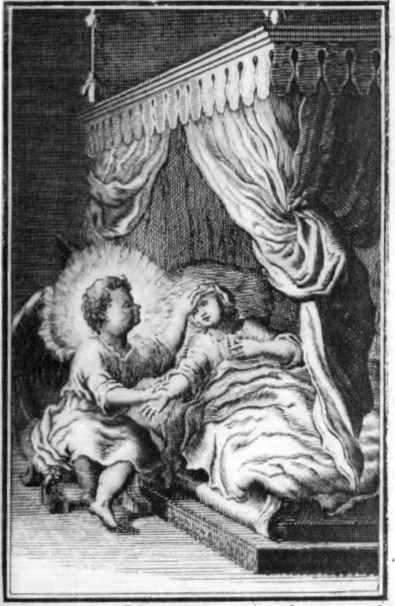

Miserere mei Domine, quoniam infirmus sum: sana me Domine, quoniam conturbata sunt ossa mea! Psal. 6.

EMBLEM III

Have mercy on me, Lord, because I am weak:
Lord, heal me, for my bones are shaking.

Have pity on me, my adorable Lord;
My body is weak and languishing!
Every moment diminishes my being:
You alone can heal me, O my celestial Love.

Ah, the evil within me is most insupportable
The evil destroys my body;
If I could please you
I would put the evil outside of me.

Heal me, change my heart, that I may be content to
Endure each day's thousands of various torments!
If I can be your lover
I desire this only in the whole universe.

I fear neither nothingness nor pain
If I can be a part of your Love;
If I can bear your yoke,
I lose without regret the light of day.

IV.

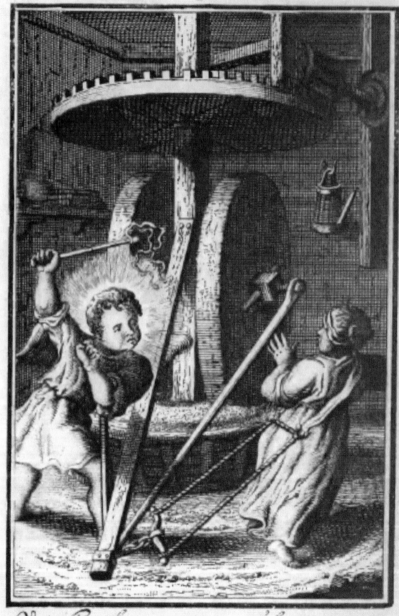

Vide humilitatem meam et laborem meum
et dimitte universa delicta mea! Psal. 24.

EMBLEM IV

Look at my state of humility and difficulty in which I am found; and forgive me all
my sins.

I know my iniquities
And the immensity of my offense:
Look at my penitence
And deal with me, Lord, according to your will.

I will not complain about work if it is difficult,
I wish to suffer more evils,
If this work could make me
Feel the pain more deeply.

Ah, what am I, Lord? Strike, double your blows,
Spare not this rebellious heart.
I merit your wrath,
Ah, wound me and make me more faithful!

I detest my ungrateful heart,
I love my chastisement, I find this equitable:
In the work that annihilates me,
I bless in secret the blows which Love accomplishes.

Ah, redouble my blows; erase my sins,
This is, dear Lover, all that I ask:
Never change my work.
Your wrath is all that I understand:
If it pleases you, all your torments
Will make me content.

V.

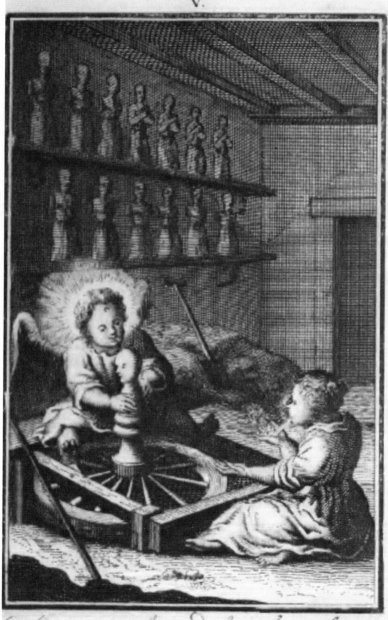

Memento, quæso, quòd sicut lutum feceris me, et in pulverem reduces me! Job. 10.

EMBLEM V

Remember, I pray you, that you have made me as a work out of clay, and in only a short time, you reduce me to dust.

You told me, my Lord, that you created me out of dust,
And I will return to this before long:
And instead of rising up, I must always descend,
And abandon myself into contempt and pain.

O You, my only hope in my long misery,
By forming me in this way
Imprint me with this lesson:
I am nothing but dust!

Could my self-elevation deliver
Understanding of my origin?
Yet if I am in my abyss of nothingness
I will return to the Divine Essence.

My simple and pure spirit emanates from my God;
My body comes out of the earth
Each returns to its own place,
The body to dust, the soul to the divine sphere.

O sovereign Love, transport my spirit
And the abyss in its place!
My body returns to dust,
And the spirit participates in happiness one day!

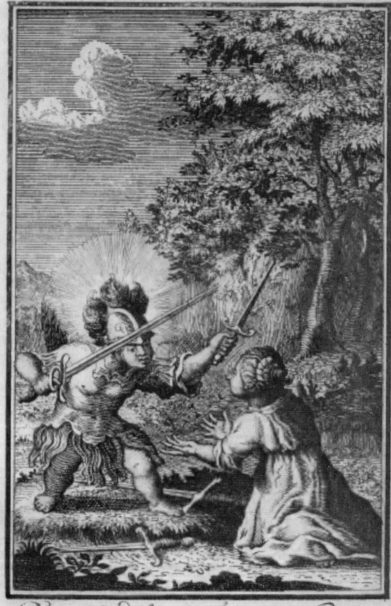

Peccavi. Quid faciam tibi, O custos hominum?
quare posuisti me contrarium tibi? Iob 7.

EMBLEM VI

I have sinned: what shall I do to appease you, O Savior of humanity. Why have you placed me in such a state contrary to you?

I have resisted you, pure and divine Love,
I have resisted; what great insolence!
Ah, why do I suffer again the day?
No, while trembling, I ask you for grace.

All of my heart surrenders to you;
It is done, I give you my weapons;
Worthy of your wrath
I hope for nothing except my tears.

You have disarmed me, O very charming Conqueror!
I must be your captive,
You have raised my heart:
I do not fear anymore what happens
In combat with you, Divine Love.
I am genuinely delivered from evil,
My soul has lost all fear,
And I am exposed to your blows.

Punish, pardon, you that are my master.
These blows from you make my heart happy:
This heart would be a coward and a traitor
If it deemed your punishment too harsh,
You are the author of my being
And you have given me your love.

VII.

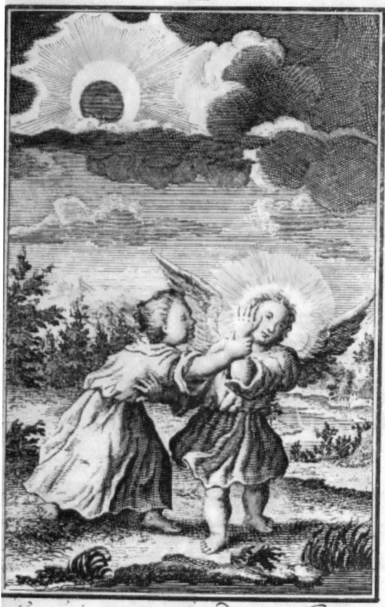

Cur faciem tuam abscondis et arbitraris
me inimicum tuum? Job. 13.

EMBLEM VII

Why do you hide your face, and why do you hold me as your enemy?

Dialogue between the Soul and the Lord

The Soul
Oh, do not hide your friendly face from me!
I cannot bear this cruel chastisement:
Yet this punishment brings a good advantage
To deliver me from an even harsher torment.

Holy and Sacred Love, do you bring other pains?
Deliver me into your fire:
Train my body with discomfort
But do not take away the charms of your eyes.

Alas, divine Love, I am punished enough,
Let me see you for a moment!
If not, I'll lose my life,
Have mercy on me, beloved Lover!

Our Lord
Do you not see, very indiscreet Lover,
That you can see me again?
Is your heart without desire and holiness?
Is it subject to my will?

Do not be troubled; suffer my absence
To punish you for your error
And your foolish resistance:
It will be better to purify your heart:

You must abandon yourself to me,
Allow me to do my pleasure.
If you loved me like I want to be loved,
You would form only a single desire.

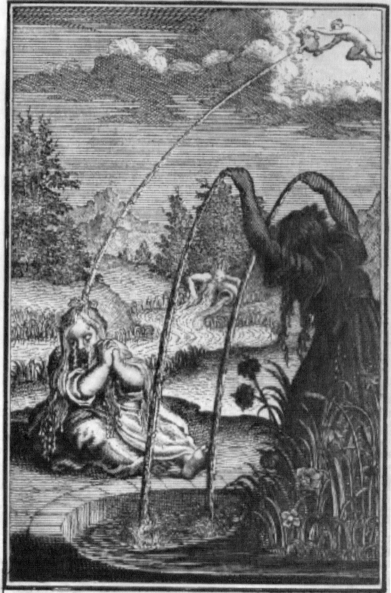

Quis dabit capiti meo aquam et oculis
meis fontem lacrymarum? Hierem. 9.

EMBLEM VIII

Who will give water to my head and make my eyes a fountain of tears, crying day and night?

Thus the still heat of love
Melts the heart and distills tears;
If it is not dissolved every day,
It is hardly in love with the divine charms.

This is the first effect produced by the beautiful fire:
But the Lover will pass through an even more ardent fire
In the heart of God who the soul loves;
This is the middle place
Between the Lover and God.

Weep, my eyes, weep, change into a fountain,
In order to obtain
The sovereign charity
That alone will unite you with God.

IX.

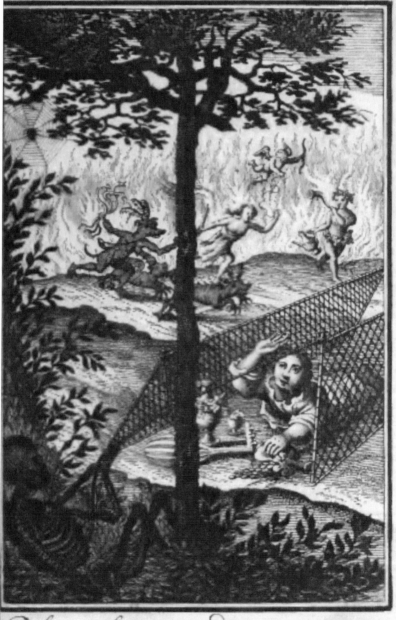

*Dolores inferni circumdederunt me, præcc-
cupaverunt me laquei mortis. Pfal. 17.*

EMBLEM IX

I was besieged by the pains of hell, and the traps of death stretched out before me.

Wretch that I am, to what am I now reduced?
Death that drags me to hell,
Shows me my certain loss
I can see where death takes me.

I'm dying in these nets,
My soul is already prisoner;
Hell holds me in its nets
And does not allow me to hope.
Great God, come rescue me;
If not, I am ready to perish.

I see my Savior with a helping hand
Who instantly shatters my bondage:
His help to me is favorable!
Rekindled hope fills me with goodness.

Ah, I pull myself together,
And I no longer fear either death or hell:
If some day my heart loves you,
I laugh at hell's effort.

Forgive my plan, let me follow you,
O my mighty Deliverer!
And, if you want me to live,
Let me live for your honor!

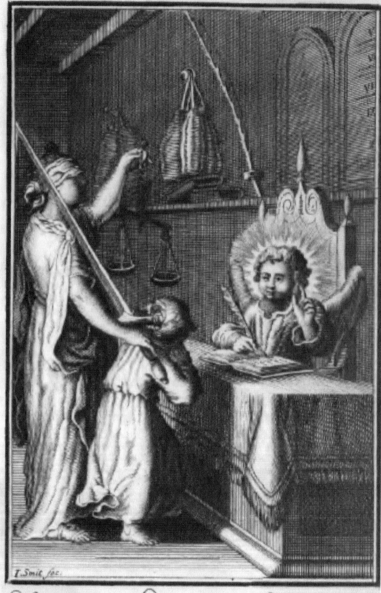

I.Smit fec.

Non intres in judicium cum servo tuo, quia
non justificabitur in conspectu tuo omnis vivens!
Psal. 142.

EMBLEM X

Do not enter into judgment with your servant.

Your Justice is holy and equitable!
I am delivered into your hands,
Divine Master of my destiny:
I am not able to account for myself.

You possess all my good; I have given you everything,
I cannot answer for anything,
Love is my guarantee, you have allowed me
To be presented to you without shame.

Alas, if you took account of me,
I would soon be reduced to dust;
My spirit all full of terror
Would wait trembling for your lightning.

To avoid this great calamity
I have left behind my traitor self;
I have given all, Lord, and
Rely on you in my annihilation.

I am of no count, O my Sovereign Good,
Neither in my work nor my suffering:
If I rest in my nothingness
Can you exercise your vengeance on me?

Because of this I welcome your august law, and
The Justice that is dear to me:
But I do not see you, O my King,
Where does your anger fall:
Lightning bursts upon my body:
I do not fear these efforts;
For in my nothingness, I welcome them.

Ah, Divine Master, alas, in that terrible day,
Do not judge me except by your love.

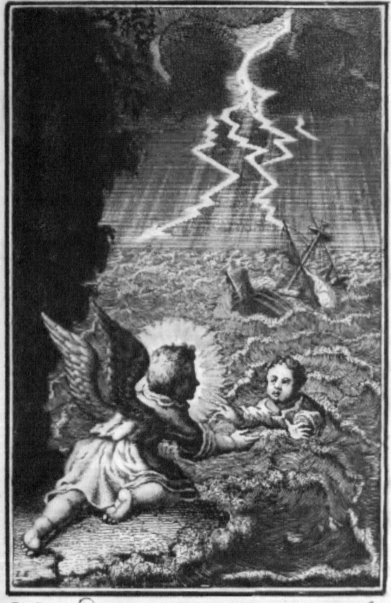

Non me demergat tempestas aquæ, neq̃ absorbeat me profundum! Psal. 68.

EMBLEM XI

The tempest overwhelms and I am at the point of being buried in the abyss.

I am nearly destroyed by the storm and the waves,
Falling down on me, I see this horrible tempest;
Lightning strikes on my head
Taking away my hope and all rest.

Come to my help, only Author of my flame,
Without you, without you, I will perish:
Guide my troubled soul;
Alas! Come down to help me.

Ah, it is not in vain, great God, that I call you;
You come to my piercing cries;
And in these most pressing dangers,
Your faithful love appears!

I was nearly engulfed in the depths of the sea,
I was buried in the waves;
But your grace without waiting
Removed me when I was swallowed up.

Our Lord
I pulled you out for an even larger shipwreck
I want you to be destroyed by my love.
This is where you will find one day
Both your loss and your advantage.

The Soul
Put me, Lord, in the state where I am,
O you, Lord, in whom I hope.
My heart is very much in love with you,
And I want to satisfy you.

Make, make me, only for your pleasure,
Deign to give me constancy;
I no longer fear suffering,
I already feel for this a sovereign desire.

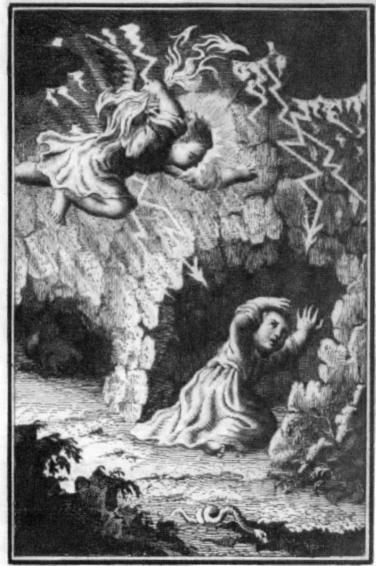

Quis mihi hoc tribuat ut in inferno protegas me, et abscondas me donec pertranseat furor tuus? Iob. 14.

EMBLEM XII

May I have the grace that you would cover and conceal me in hell, until your wrath is entirely past!

What shall I do, Lord, to avoid your blows,
Where to hide from your anger?
Is there an underground haven
Where can I take shelter from your righteous anger?

I am penetrated by sorrow for
Having drawn down your vengeance.
I acknowledge well
Your displeasure at my offense.

Alas, if you wish to punish me now and,
Taking hold of me, to cease your wrath,
This would end my languor,
Oh Lord, in whom I hope!

The sorrow caused by displeasing you
Gives me a cruel pain,
My heart ceases to be rebellious
Under the effort of your blows, my heart weakens.

Do not abandon me to my own misery,
Oh you, thou, Savior of humanity.
Suspend in your time your severe justice
Reach down to protect me by your powerful hands.

I know your mercy
Surpasses our iniquities:
If I receive your forgiveness and your favor
I am satisfied with my humility.

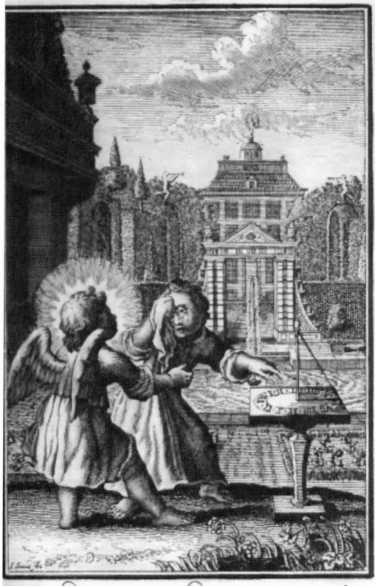

Nunquid non paucitas dierum meorum finie-
tur brevi? Dimitte ergo me ut plangam paul-
lum dolorem meum? Iob. 10.

EMBLEM XIII

Will the few days I have left soon be gone? Give me a moment of relief, so I can breathe, even in my sadness.

Leave me to cry in my sorrow,
Sweet architect of my martyrdom.
O you, for whom my heart sighs,
Soon change your fury!

Out of pain I cry over my offense,
And you bring me relief:
Let my penitence flow freely,
You favor me through your vengeance.

I am already at my end, and my days in a shadow
Are vanishing in an instant:
Ah, in this dark place
Let me weep, dear Lover.

You want me to be consoled
Even after I have displeased you,
And your divine word
Will not let me forget all that you are.

Your caresses full of charms,
Even despite my heart, dry my tears.
I already feel interior peace in my spirit:
And I do not feel cruel alarms
That heighten anxiety.

Since I abandon my soul to you
I taste a divine calm, divine Lover,
I sense the birth of your flame
That brings contentment.

Do not suffer, Lord, my heart to offend you
Call me into punishment for my sins:
I adore your vengeance
If it removes the stains from my unfaithful heart.

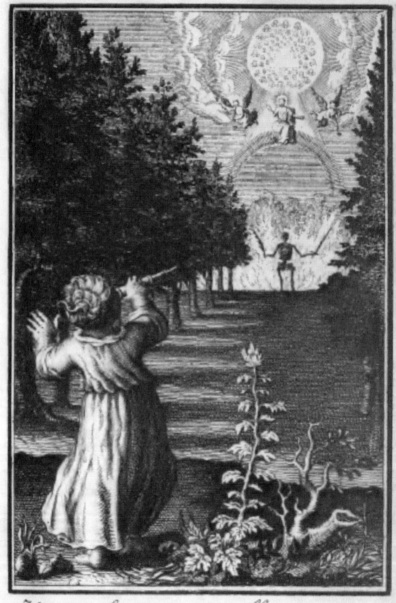

Utinam saperent et intelligerent ac novissima providerent! Deuteron. 32.

EMBLEM XIV

Ah, if they had the wisdom! They would understand my way, and they would foresee their end!

You show me, Lord, this future glory,
In order to console my heart:
This pleases the strong person;
But I want to love you with much more fervency.

Hide me in this reward
That you keep for your children:
Let me love you with constancy
And expect nothing except your presence.

When you have given me
Flames as my portion,
I want today to love you
And serve you with courage.

But what could I have if you do not give
The pure love that I desire?
This is the effect of your goodness;
I would like to request a harsh martyrdom.

After I have acquired this, I have nothing to give,
For I have the same poverty:
I am entirely abandoned to you,
And show you, great God, that I love you.

Receive my nothingness; it is my only good:
This void is my only portion.
I want you, or I want nothing;
Only, Love, my only inheritance!

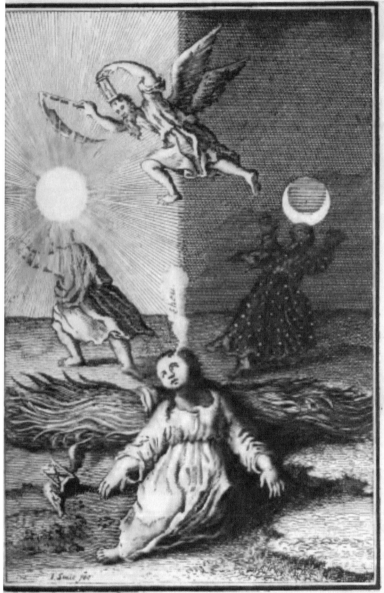

Defecit in dolore vita mea et anni mei
in gemitibus. Psalm. 30.

EMBLEM XV

My life is consumed with sorrow, and my years pass with sighs.

My days are passed in groans,
My life slips away in sadness:
But, O King of all Lovers,
I will be set free.

I see that death seems to approach from afar;
I dare not testify to joy:
I fear your anger.
Alas, let me see you!

You may suddenly purify my heart,
I am restored if I conform to you,
In spite of this weak languor
I remain in the nothingness of humanity.

That freed from all I no longer live;
Lift me, my Savior, to you:
That I may live with JESUS;
For him only I adore and love!

I am reduced to nothingness:
His love ravished me with a new vitality,
Which made me run incessantly
Toward this source of light.

I cannot act; I can only suffer;
My heart, my heart, does not grieve;
It feels a profound peace,
As if it were alone in the world.

I do not know myself anymore, I know not if I am,
I have neither strength nor power;
Your arms fervently hold me yet
Do not deprive me of faintness.

I have no will, I have no desire,
My soul is dead to all things
Is it time, dear Bridegroom, to die
And to be reunited to the first cause?

Book Two

The Second Sigh

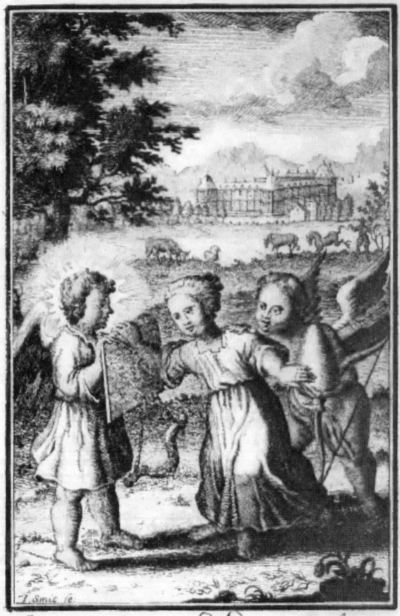

Concupivit anima mea desiderare justificatio:
nes tuas. Psal. 118.

EMBLEM XVI

With great fervor my soul desires your judgments.

Withdraw and go away, deceptive love,
I detest and I abhor you.
Since the time I have given my heart
To the sovereign God whom I love and I adore,
I have not listened to your profane discourse:
Dare you come again in order to
Disturb me in my chaste love?

The one who holds my heart will defend it well.
Leave your bow and your arrow,
Or withdraw to a new place:
The flames of love reduce me to ashes
I taste nothingness here:
Where will I find your charms,
Or perhaps I will place attention on a vain object?

Oh my celestial Bridegroom,
My eyes, my chaste eyes, do not see you:
All of the other objects are funeral objects
That let me die in the midst of darkness.

You are my happiness, you are my light;
I know of you, sovereign Beauty.
It is you who penetrate the center of my soul,
It is you who burn me with a sweet flame,
I will never get well without you,
Burn always within my heart, or let me die!

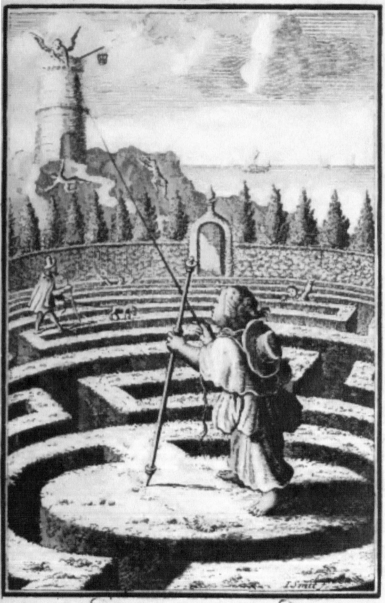

J.Smit fecit

Utinam dirigantur viæ meæ ad custo-
diendas justificationes tuas! Psal. 118.

EMBLEM XVII

Come down, Lord, to set my way with strength so that I keep the justice of your ordinances.

In this terrible labyrinth
So filled with twists and turns,
I walk, dear Bridegroom, without fear
Trusting in your help.

I look how some fall far off a precipice
The most daring and the most filled with light:
I go without sight and without artifice
I am entirely abandoned to the care of my Lover.

This blind man is a great example
Of abandonment and faith;
When I behold from afar
I contemplate with delight.
He follows his small dog and walks with assurance
Humbly and without a false step.
I am guided by your providence
And do not I abandon myself?

Anyone who relies on his own strength,
On his own guidance and strength,
With his pride serving as his lead
Immediately falls over the precipice.

We place ourselves in great danger
When in our pride we rely on ourselves;
Ah, that daring is extreme!
You invite me to place myself
Under the care of Providence.
This admirable wisdom,
Leaves me no room for concern.
This life is a labyrinth;
If you want to walk with certainty.
Then our faith is blind and without pretense
Our love pure, and without disguise.

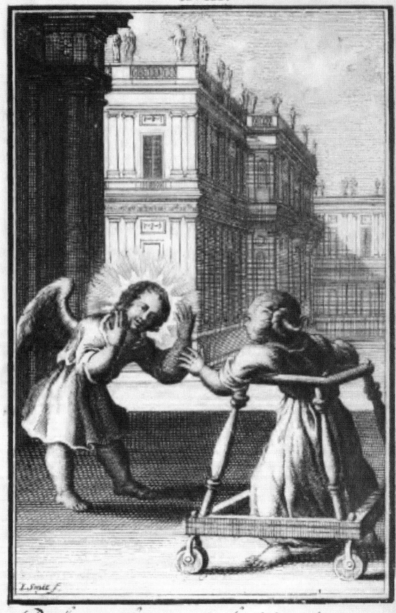

Perfice gressus meos in semitis tuis, ut non
moveantur vestigia mea. Psal 16.

EMBLEM XVIII

Steady my steps in your paths, that my feet be not shaken.

I am only a child, I cannot walk,
Divine Love, oh, lead me to yourself!
My weakness, O God, will forever touch you:
It is great and extreme!

You teach me the true paths
That lead to justice:
Without your powerful hands, I will fall into the slough;
Followed by the abyss and precipice.

I tremble with every step: ah, come help me!
This support does little
Without the support of my loves
I can at any instant go back.
Love, do not abandon me;
Stay and guide my every step.

XIX.

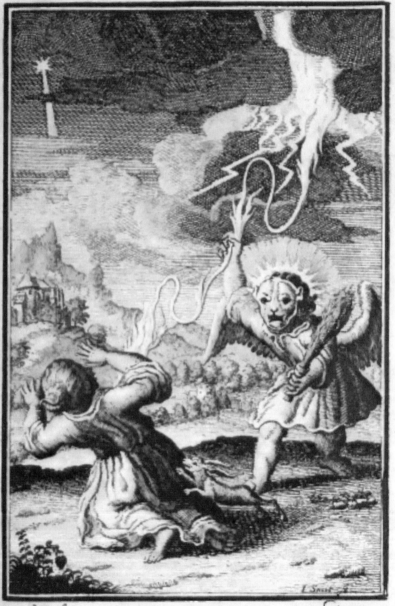

Confige timore tuo carnes meas, à judiciis enim tuis timui. Psal. 118.

EMBLEM XIX

My flesh is pierced by fear of you, for I am seized with terror at the sight of your judgments.

Lord, my vile dust,
Full of nothingness and vanity,
Unworthy of your anger,
Must attract your kindness.

No, no, continue your blows,
Divine love, I apprehend;
I fear your wrath:
Alas, my grief is great!

Where can I go to hide?
My fear grows without ceasing;
Because of your avenging justice
You find me without effort.

I see, my divine Master,
Your mask of fury.
You want to hide me, perhaps
My evil becomes smaller as I fear.

Alas, I am nothing!
Do you want to lose me now?
You, my principle and my first cause,
Can reduce me to nothing.

So remove your lightening;
I do not need your spears beating upon me.
For you reduce me to dust,
By one look from your eyes.

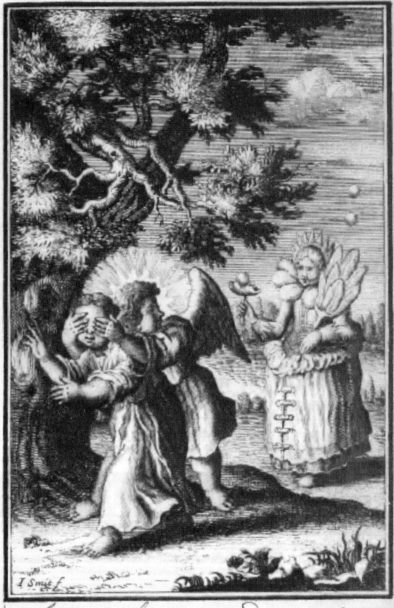

Averte oculos meos ne videant vanitatem.
Psal. 118.

EMBLEM XX

Turn away my eyes lest they look at vanity!

All the pleasures that one can value in this world
Flow faster than the waves:
Blessed are those who turn away their eyes
From the world's flattery that captures by its language.
This brings a double advantage;
Their spirit delivers them from odious objects, and
They may contemplate the King of the heavens.

It is you, divine Love, who make these wonders:
As soon as one abandons to you
You guard us in the world with its blows, and
Overwhelm us with unparalleled grace.

You make us hate the foolish vanity
And love the noble truth,
You lead us according to your wisdom.
We avoid insipid insolence.

Ah, hide me always from this deception!
End this seductive ruse that
Enchants with these false pleasures,
And corrupts the heart of your Lover!

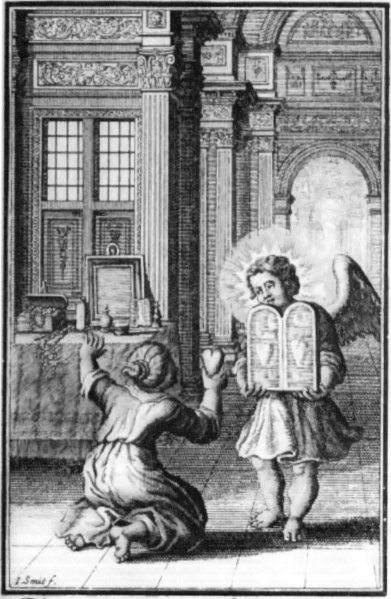

Fiat cor meum immaculatum in justifica:
tionibus tuis, ut non confundar: Psal. 118.

EMBLEM XXI

Let my heart be kept pure in the practice of your ordinances filled with justice, so that I may not be put to shame.

Ah, receive my heart, I no longer want to use it.
My Lord who loves me,
Grant me this favor.
Come down with your fire.

If I am in your hands you make me faithful,
I will never be deceived,
Place me on what pleases you.
Finding my home on your holy law, I am renewed.
Without leaving your divine feelings,
My heart remains always in your hands:
Lead me, Supreme Good:
Even more, let me lose myself in you.

Let it never be that I search in vain,
That you would be hidden from view,
For engulfed in the new Essence,
I am eternally grateful for this happy destiny.

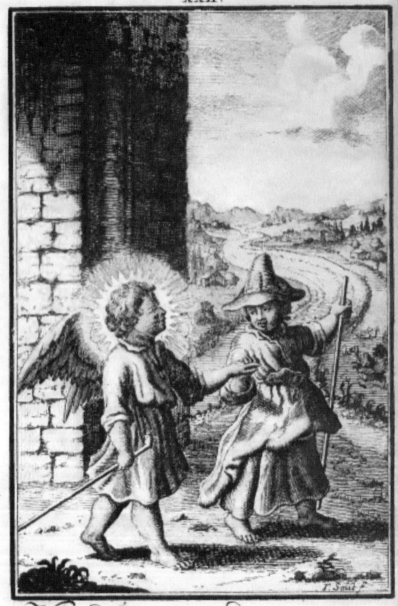

Veni dilecte mi, egrediamur in agrum,
commoremur in villis. Cantic. 7.

EMBLEM XXII

Come, my Beloved! Let us go forth into the fields, and lodge in the villages.

Come, my dear Bridegroom, stay in the village,
Leave the city and trouble,
I want to follow all your steps;
I would rather live in the wilderness.

Once away from the world and its noise
I will love you and speak with you without ceasing,
I have the quiet of the night;
Here I contemplate divine wisdom.

Walking with you, I cannot get tired,
You give me new strength:
Following these routes eternal
We walk day and night, without even thinking.

Start right now, my adorable Master,
Without retracing our footsteps:
Ah, I would perhaps mislead,
Divine Love, if I did not have you.

What do I say? It seems true without doubt.
If you leave me for a moment
Ah, what detour will we take,
If I do not have you as a guide, my faithful Lover!

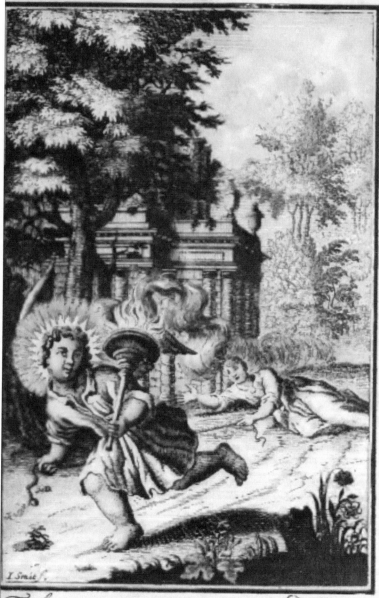

I. Smis

Trahe me, post te curremus in odorem
unguentorum tuorum. Cantic. 1.

EMBLEM XXIII

Draw me: we will run after you in the aroma of your perfumes.

Take me, my divine Spouse,
Then we will run after you,
For the beautiful aroma of the celestial perfume
Pulls me from my fatal languor
Revives and delights my senses:
This perfume, more sweet than incense,
Invites me without ceasing to follow you;
Without this divine perfume, I will not live.

Because you are a novice, still your love,
Replied the Bridegroom in turn:
Wants soft, attractive perfumes;
You are a weak lover!

I know a path solid and productive;
It is the way of my pure love.
One should not search for the perfume, the tenderness;
One is led by wisdom:

It is the sorrow, pain, and torment,
Distinguishes the perfect Lover.
What! Do you want to walk on flowering roses
When I in torment had my life terminated?
Follow me in difficulties, die on the cross;
You have dignified my choice.

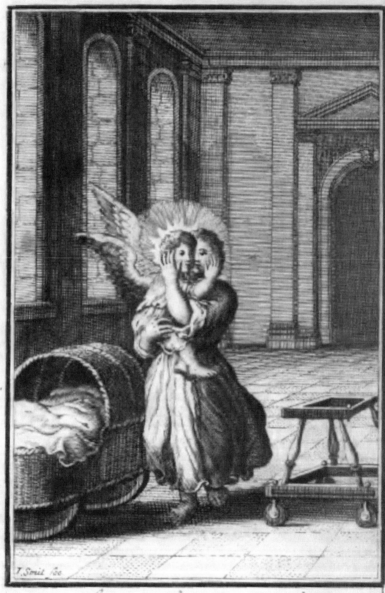

J. Smit. fec.

Quis mihi det te fratrem meum sugentem
ubera matris meæ, ut inveniam te foris et
deosculer te, et jam me nemo despiciat! Cantic. 8.

EMBLEM XXIV

You give to me, O my brother who sucks the breasts of my mother, and I find you.
I give you a kiss and no one will despise me!

Ah, give me my brother,
That fed from the breasts of my mother!
That I may open my heart,
And become enflamed with fire!

These chaste kisses are the ones I favor
I no longer fear those who scorn me:
For I see the fulfillment;
Everyone sees my transports.

Divine infant, author of my long suffering,
You revive my hope;
I find in you a gift; this exceeds all pleasure!
I will explain my desire;
It is for me to be united with you without division:
Bring me this great advantage,
Then I do not fear nothingness
Powerful possessor of my only good.

XXV.

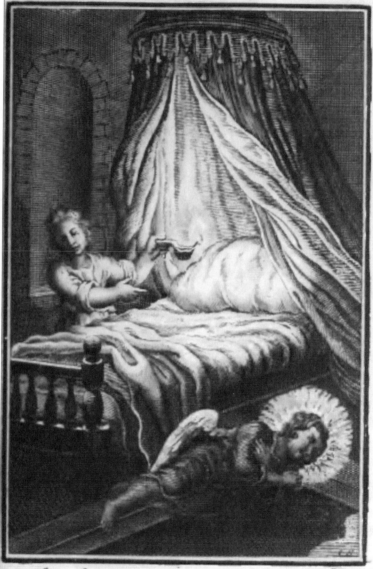

In lectulo meo per noctes quæsivi quem di-
ligit anima mea, quæsivi illum et non inveni.
Cantic. 3.

d

EMBLEM XXV

Upon my bed at night I looked for the one my soul loves: I sought him and found him not.

Why do you search in the bed
For your Bridegroom, unwise Lover?
In vain do you search in the dark night:
He does not retire there.

Come forward a little, here on the Cross
Pierced sweetly, adorned with thorns;
You will never find him except on this wood,
Sorrows and pain are the divine way.

It is in vain that we search for
Jesus in the repose of a sluggish rest:
Never will we find him there;
He lives in sorrow, he died in grief:
He is constantly fatigued;
To find the sinful soul,
His repose is in torment.

Suffer, die to all; we will never find him without pain,
The noble Bridegroom of our heart.
This is a very vain search
To want to find our Savior in the bed.

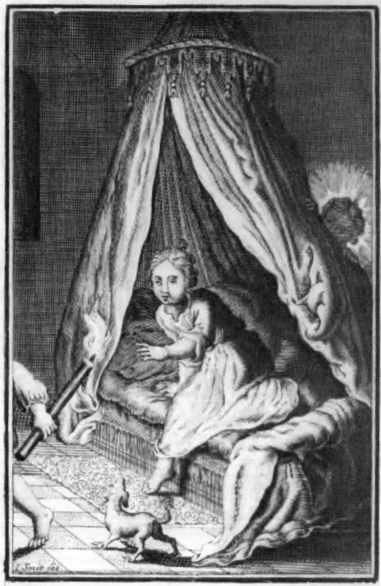

*Surgam et circuibo civitatem, per vicos et
platcas quæram quem diligit anima mea:
quæsivi illum et non inveni. Cantic. 3.*

EMBLEM XXVI

I will rise and go about in the city; and I will seek in the streets and in the public places for the one who is the Beloved of my soul: I have searched but I found him not.

No, no, I do not want to live in this repose,
I run everywhere searching for whom I love:
I look without finding,
I will never be the same.
A great city I go all around
To testify to my love.

What are you doing, O foolish lover?
Ah, you look in the evil, always wasting time!
You do not follow holiness
And you remain guided by your senses.

You search in the bed; Jesus is on the Cross;
He is with you; you run in the city,
You deceive by this choice
You do not leave your small habitation.

Love, suffer for him, who will take your heart
As his place of retreat:
Then you will be satisfied,
In all times and places, possessing happiness.

You will taste peace even in suffering,
You are delivered from nothingness
And your content heart possesses all good
Having all rest with abundance.

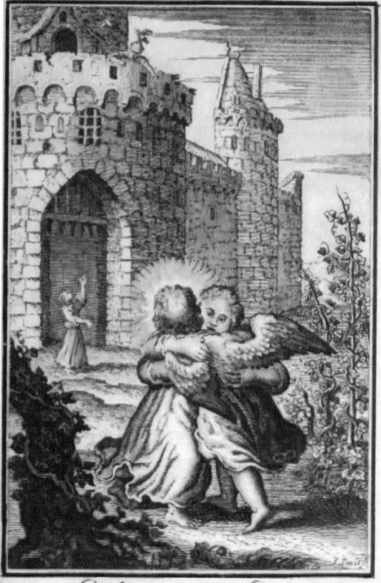

Nūn, quem diligit anima mea, vidistis? Paullulum
cum pertransissem eos, inveni quem diligit ani:
ma mea: tenui eum, nec dimittam. Cantic. 3.

EMBLEM XXVII

Have you not seen him whom my soul loves? Shortly after I passed them, I found him whom my soul loves. I held him, and I will not let him go.

When I left behind all creatures
I found my celestial Bridegroom:
When I followed him very naturally
I was full of a sweet goodness.

I am yours, my faithful lover,
I will not suffer more of his distance from me;
Today I swear eternal love,
And forever inviolable faith.

Remain, dear Bridegroom, in our solitude,
I discover in you my fire:
I will no longer suffer chaotic anxiety:
That you possess me is the purpose of my wishes.

Then separated and far from anything
I will tell you my love:
Ah, let my heart rest in your heart,
And there repose forever!

XXVIII.

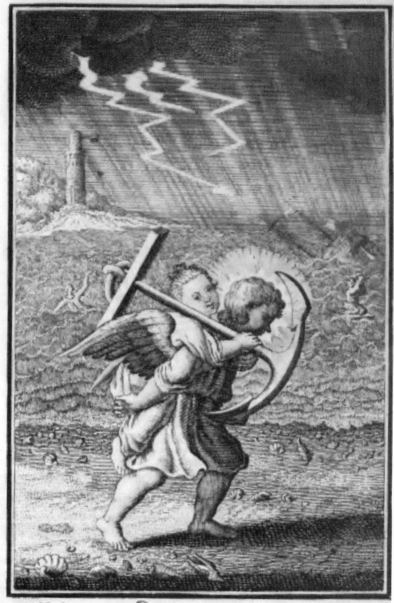

Mihi autem, adhærere Deo bonum est;
ponere in Domino Deo spem meam. Psal. 72.

EMBLEM XXVIII

But for me, all my good is to stand united with God, and put all my hope in the Lord, my God.

It is good for me to join you,
And put my trust in you!
Is there anything, my divine Bridegroom,
More charming than this adherence?

Here our hearts are united, and we have only one will,
My hope is not in vain;
I feel the divine power,
Who carries me in the sovereign hand.

I am afraid neither of pain nor danger,
Because I am carried by God whom I adore
The torment seems light!
I love it even more than pleasure which I abhor.

What a change, great God, I discover in my heart!
I loved the vanity that I now detest:
Now I fear when pain lessens,
The torment strikes me as kind.
It is you, Divine Love, who has done this well
Because without you, I am nothing.

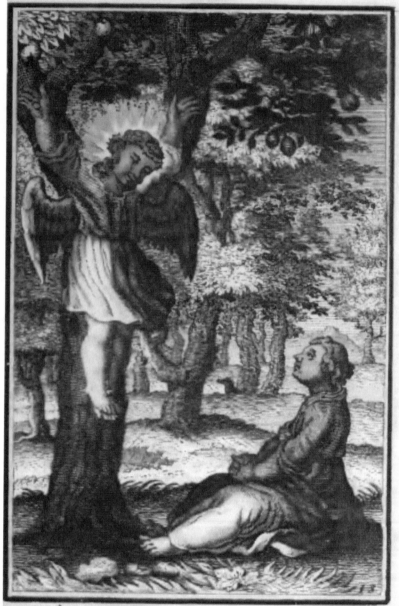

Sub umbra illius quem desideraveram,
sedi. Cantic. 2.

EMBLEM XXIX

I rested in the shade of the one I so desire.

Alas, I have suffered pain, toil!
I have wandered and been a vagabond,
I have found nothing in the world
That serves to relieve me from evil.

Fortunately I found this wood
Whom my soul loves:
By extreme happiness,
My heart made this worthy choice.

I have found my rest under this fertile tree,
Where love attaches me;
I have chosen this as my home,
My heart will never leave.

I rest in its shade,
This is where I live in the night and the day:
My home seems dark,
This pleases my Love.

There I found fruits of exquisite sweetness;
Others would find them bitter:
For myself, I frankly confess
These fruits are unsurpassed in the universe.

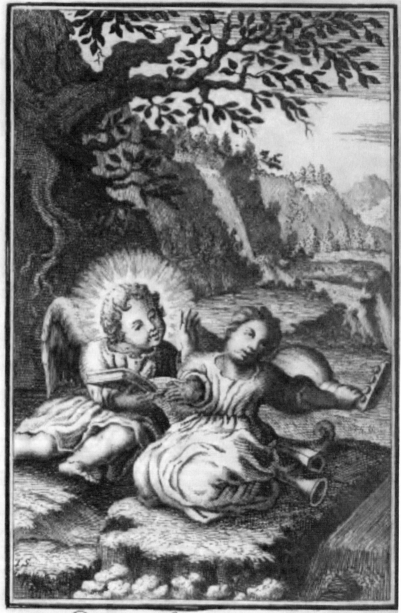

Quomodo cantabimus canticum Domini,
in terra aliena? Psal. 136.

EMBLEM XXX

How shall we sing the songs of the Lord in a strange land?

The Soul
Alas, how do I in this strange land
Sing again the holy songs?
When I was with you, my Lord and my Father,
I created sacred concerts.

At the present I can neither read
Nor sing songs:
I must, however, sigh;
My sad heart has no melody.

Our Lord
It is I, it is I, who wants my glory for you
You can sing in all places:
Because darkness never covers,
The love and flames of my fire.

The Soul
Let's sing, dear Bridegroom: the harmony is beautiful.
When two hearts become in love,
With their chaste and faithful flame,
That concord is marvelous!

This is our concert together,
We do not strike any false notes,
We never catch sight of any negative:
This is what we see, when love is intense,
The other responds at the same instant:
Never on a different note:
O this Canticle is charming,
That manifests the divine love!
Sing, my heart, and night and day:
We sing when we are full of love.

Book Three

The Third Sigh

Adjuro vos, filiæ Hierusalem, si inveneritis
dilectum meum, ut nuncietis ei, quia amore
langueo. Cantic. 5.

EMBLEM XXXI

I beseech you, O daughters of Jerusalem, if you find my beloved, tell him that I languish with love.

You, who I perceive, my faithful Companions,
You who travel the countryside,
Today if you encounter
My Bridegroom, tell him that I languish for love.

Alas! I had run like you
To meet the one I love:
All my work seemed sweet to me
To meet this kind Bridegroom:
But now my languor is utmost.

My heart is penetrated with the divine charms,
And yet I cannot make a step,
I find my rest in this enchanting love;
And this repose reduces me to crisis,
Alas! I cease to languish
If I may hear again his adorable voice.

Tell him that I am dying;
Paint my torment for him, O my amiable sisters:
Express to him that his Lover,
Prepares to die under the weight of her sorrows.

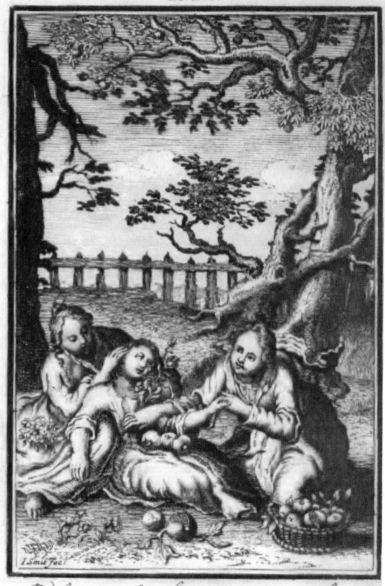

Fulcite me floribus, stipate me malis, quia amore langueo. Cantic. 2.

EMBLEM XXXII

Support me with flowers, fortify me with apples: because I languish with love.

Alas, I am dying! Ah, cover me with flowers,
Do not abandon me, my sisters,
Surround me with apples,
Found in the garden of the Bridegroom:
Oh, hide me from all of humanity,
And I am alone with you!

"What may I serve you, incomparable Lover,
These apples and these flowers? You are languishing;
He gives you love with celestial favors:
Do you fear losing the flowers?

"These are only light bagatelles
Who now you should be relieved of:
These thorns and the cross are new flowers
The Bridegroom wants to share.

"Leave the favored apple;
We must become generous
If you want to please your celestial Bridegroom;
This is the way to attract him."

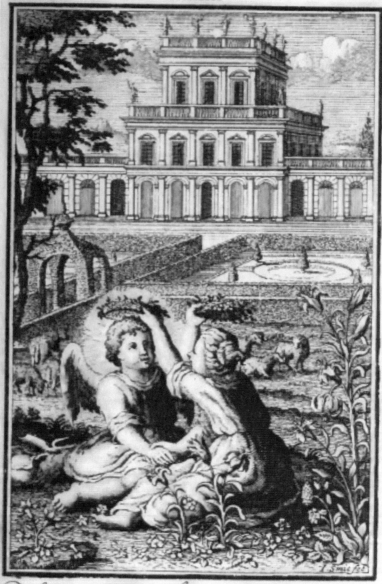

*Dilectus meus mihi et ego illi qui pascitur:
inter lilia; donec aspiret dies et inclinentur
umbrae.* Cant. 2.

EMBLEM XXXIII

My Beloved is mine, and I am his. He nourishes me among the lilies, when the day begins, and the shadows gradually dissipate.

It is done, it is done; I do not want flowers.
Except for a crown
For my celestial bridegroom; and I abandon myself to him
And give a present of gentle sweetness.

The lush lilies surrounding me
Represent my purity;
And my Bridegroom gives these;
Without him all is vanity.

Dear and divine Bridegroom, ah, guard your favors;
It is you who give me these, and I return them to you:
It is not enough to have these flowers,
My heart is given to you, without ever taking it back.

We rejoice in the midst of these lilies,
Until the day begins;
Delicious are my nights,
You allow me then to speak with you!

If I am all yours, you are all to me,
My happiness, my joy is intense.
Love is my only law;
You love me: You know, Lord, that I love you.

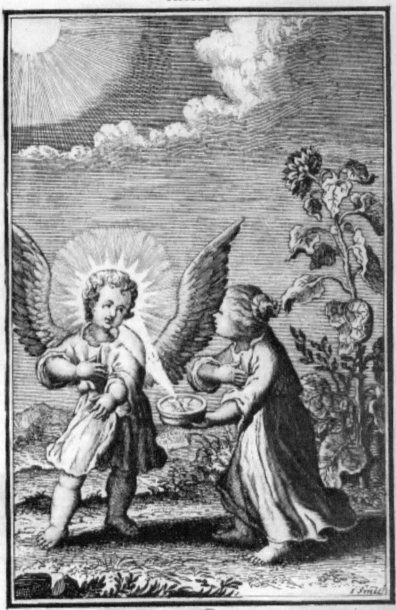

Ego dilecto meo, et ad me conversio ejus.

Cantic: 7.

EMBLEM XXXIV

I am my Beloved's, and his heart turns towards me.

My heart follows you everywhere, O my divine Lover,
Following your service like a magnet:
You mark on my heart like a compass
By your looks, by your word
Your adorable will
Turns me to you.

The sunflower also turns toward the light
It is in love with the Sun;
And unable to leave the earth,
It wants, like the sun, to tour the heavens.

My heart also converts to love,
Love is the light of my life:
He guides me in my journey,
He makes my night and my day.

If he leaves me, I am in darkness;
When he is close to me, the night becomes light;
He inspires me with his truth,
Without him all is melancholy.

Without him, I am in death;
He is my spirit, the life;
Through him I am freed from all evils
I do things without effort.

HE IS IN ME, I AM IN HIM;
This love is mutual!
Therein nothing is equivocal
Since he is my strong support.

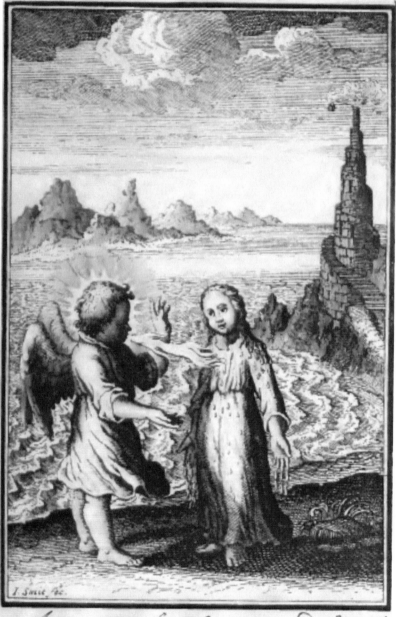

Anima mea liquefacta est, ut dilectus
locutus est. Cantic. 5.

EMBLEM XXXV

My soul melted as my Beloved spoke.

O fire pure and divine, delicious heat,
You destroy a soul in love!
I melt as soon as I hear the gentleness
Of the divine word,
Who warms my heart:
Love is a wonderful school!
The soul passes into her Lord.

She rests there in divine substance:
She is lost in her God's abyss:
The activity of a beautiful fire
Gives her a complete innocence.

It is you, divine Love, who changes us;
It is you who allows the soul to pass into love;
It is you who reduces us into a sure annihilation,
In you she finds her All, an intense happiness.
Banish propriety:
We find the truth;
And in you we discover the source.

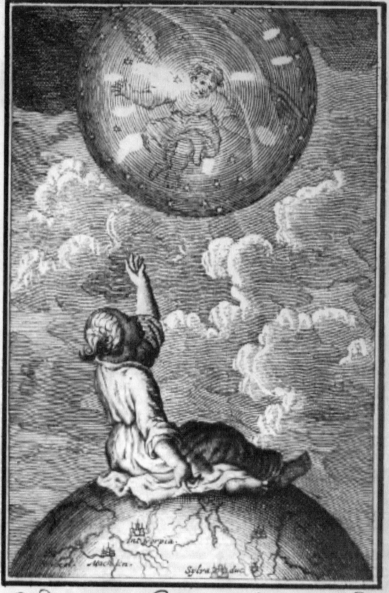

Quid enim mihi est in cælo? et à te quid
volui super terram? Psal. 72.

EMBLEM XXXVI

For whom do I have in heaven, and whom do I desire upon Earth, if not you?

After this change, what could I want
On the earth and in the very heavens?
I find neither desire nor will in me;
All passes into whom I love.

You are, O my God, for me the heaven of the heavens,
Your happiness makes me content;
You will always be glorious,
My wait is over.

All my good is in you, the One who never dies;
You are always adorable:
It is where my desire was born;
Your happiness makes mine unchangeable.

O my heavenly Bridegroom, I cannot express
What I feel in the depths of my soul:
You have deigned to imprint on me
Your character with strokes of pure flame.
Ah, never let me lose this;
It is the height of my blessings!

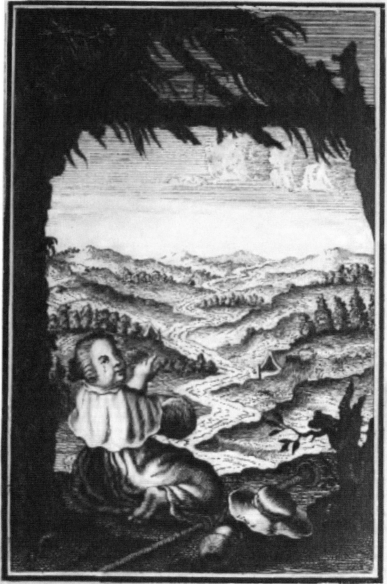

Heu mihi, quia incolatus meus prolongatus est; habitari cum habitantibus Cedar; multum incola fuit anima mea! Psal. 119.

EMBLEM XXXVII

Alas, my exile is long! I live among the inhabitants of Kedar. Here my soul is foreign.

That my exile is long, dear and divine Bridegroom!
I wait the end of my journey;
Yet your divine light
Defends me against desire for luxury.

I am in a strange land
Where I abhor the inhabitants;
Because barely any one knows you,
This doubles my torments.
Your enemies make war against me:
Because I live with them,
Without you I would be in dreadful misfortune.

I retire in solitude:
And I tell you about my torment;
And I am not worried
In the midst of a wicked people.

You are the point of my love, the sweet center of my soul;
Where your flame burns:
Why be evil and not love you!
You have reached down and enflamed me;
Why do you leave me in a rebellious people,
Can I live only for you?
Ah, ever my heart lives faithfully
Take me, my dear Bridegroom!

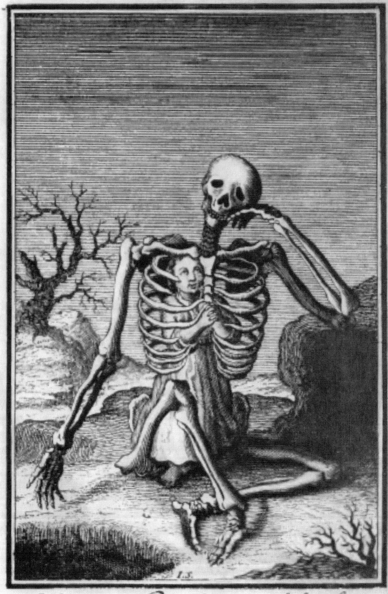

Infelix ego homo! Quis me liberabit de corpore mortis huius? Ad Rom. 7.

EMBLEM XXXVIII

O wretched person that I am! Who will deliver me from the body of this death?

I languish in a prison,
Where I, dear Bridegroom, become contrary to you:
Ah, see my affliction,
And stop me from displeasing you.

I am, alas, an unfortunate human,
Still contained within myself,
Doing nothing generous
To please the one whom I adore and love.

The Spirit attracts me higher; the body pulls me low;
For me it is a strange combat:
I would like to walk in your footsteps;
Yet despite myself, my body, my desires lead me.

Have pity, great God, on my adversity;
You know my extreme weakness:
Pull me out of this body of death;
I await your wisdom.

XXXIX.

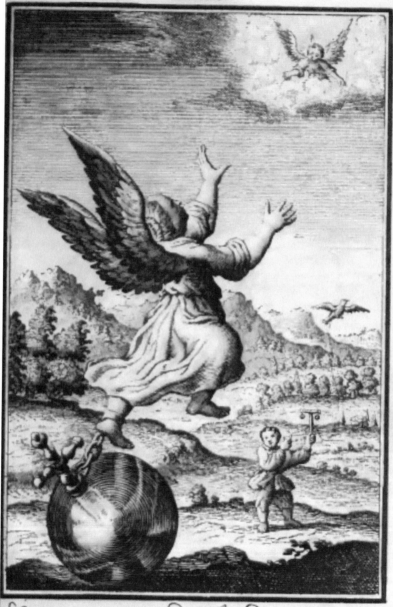

Coarctor autem é duobus; desiderium
habens dissolvi et esse cum Christo. Ad Philip. 1.

EMBLEM XXXIX

I am pressed on both sides: for I desire to be disengaged from my body and be with Jesus Christ.

My heart flies to you; my body is held to the earth;
Break these ties that hold me down;
Since you only can do this;
Let my prayer not anger you.
O you, Lord in whom I hope,
You have touched my sorrows,
You are my Lord, my Savior, and my Father.

I fervently desire to unite with you
Being far from the rest:
You know, my divine Bridegroom,
How I detest the world.

I am yours in spite of myself,
And I remain there in patience:
You will always be my law,
I live in obedience.



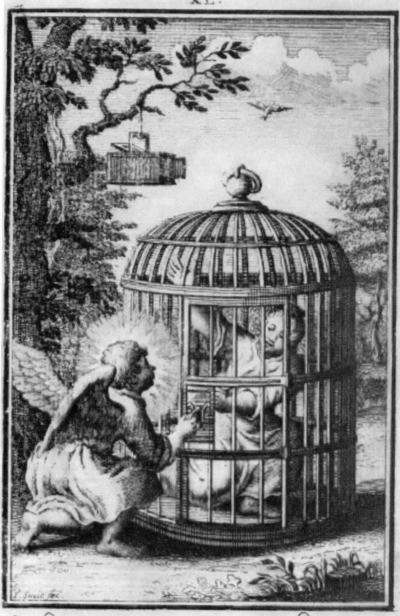

Educ de custodia animam meam ad confitendum nomini tuo! Psal. 141.

EMBLEM XL

Take my soul out of prison, so that I may bless your name.

Alas, my soul is imprisoned!
You may, dear Bridegroom, pull down the prison:
You do not listen to my prayer;
I am confused.

Ah, if you in your goodness, pull me to you,
There is a double benefit;
Because the self is a slave,
That makes me unworthy of you.

Divine Bridegroom, sweet center of my soul,
Ah! I ask for help with myself;
Because the prison is fatal to my heart
Yet the door is found only through patience:
Draw me to you, dear Vanquisher,
And I live, although in suffering,
Without complaining about my misfortune.

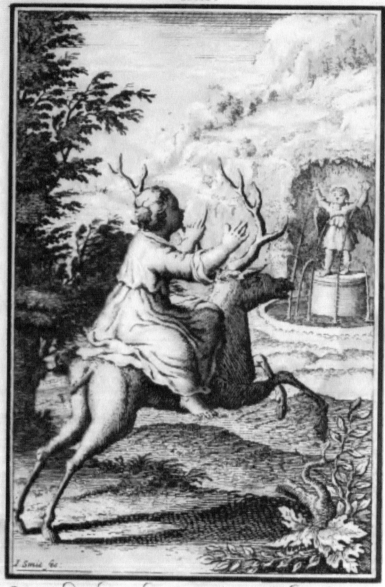

Quemadmocum desiderat cervus ad fontes
aquarum; ita desiderat anima mea ad te
Deus. Psal. 41.

EMBLEM XLI

As the deer eagerly yearns for the streams of water, so my soul yearns for you, O
my God.

The deer desires with less ardor
The clear waters of a fountain,
Then I desire, Lord,
The water that you promise to the Samaritan woman.
Therefore do not let me languish,
My change has become extreme:
You know how much I love you,
I cannot separate from this well-being without dying.

Give my thirst your inexhaustible water,
That produces in us a river full of peace;
Your kindness is infinite,
Deign to content me with blessing!

In quenching my thirst, you give me life.
Ah, have mercy on my lot in life:
Still I am enslaved,
Come, or give me death.

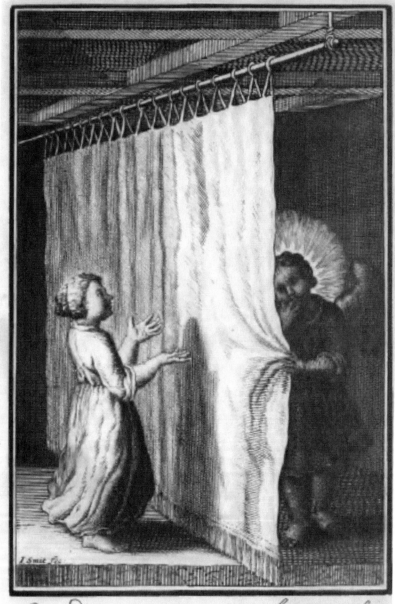

Quando veniam et apparebo ante faciem Dei? Psal. 41.

EMBLEM XLII

When shall I appear before the face of God?

The Soul
When will you give me your grace
That calls me to you?
When will it be, O divine Bridegroom,
That you give me efficacious happiness?

When will you show me your kind face?
I languish in the night and in the day:
If you will accept my love,
Remove me from my slavery.

You are my sovereign good,
My happiness, my center and my glory:
Outside of you, I desire nothing;
You have entire victory over my heart.

Will you let me languish for a long time,
Author of my humble flame? Will you let me remain moaning?
You attract me, you take my soul:
Your strong attractions make me very happy,
If we could die and die in your eyes!

The Lord
Very happy Lover, your strong tone is beautiful!
What, you think you are unhappy!
To ensure your destiny
The Bridegroom would not draw apart the curtain.

u do not comprehend this august mystery;
If you want to work for the faith,
Far from aspiring for your final hour,
Abandon your will to your King.

The Soul
When we believe in extreme love, It curves back again in faith on the self;
We have joy in its object:
The perfect resignation
Between the hands of God who is pleased in the subject.
There is no honor in what we want:
The blessing is the effect of the divine will;
And we must all turn back to his pure goodness.

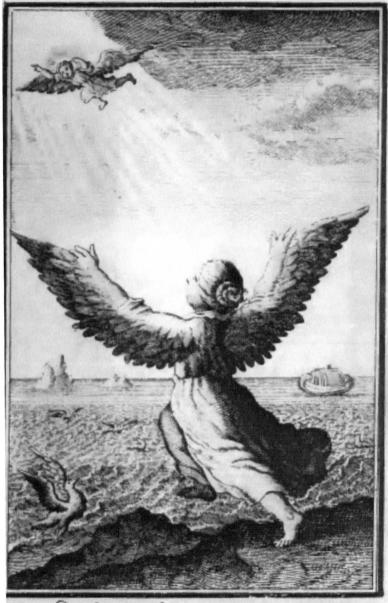

Quis dabit mihi pennas ficut columbæ,
et volabo et requiescam? Pfal. 54.

EMBLEM XLIII

Who will give me the wings of a dove, and I will fly away and find rest?

Give me, my divine bridegroom,
The wings of a dove,
So I may fly to you,
Let my love be eternal.
My spirit and my heart are no longer on the earth,
They already live in the celestial home:
Destroy, O divine Love,
My heavy and limiting body.

It is he who holds me still
My soul is already in heaven;
Ah, do, Lord who I adore,
Let me die before your eyes!

I am in extreme pain,
And in agitation:
Take me, since I love you,
And call me to you, O Lord of Zion.

Here I taste in you a profound peace,
That one cannot know here below.
Blessed are those separated from the world,
Occupied night and day by your divine charms!

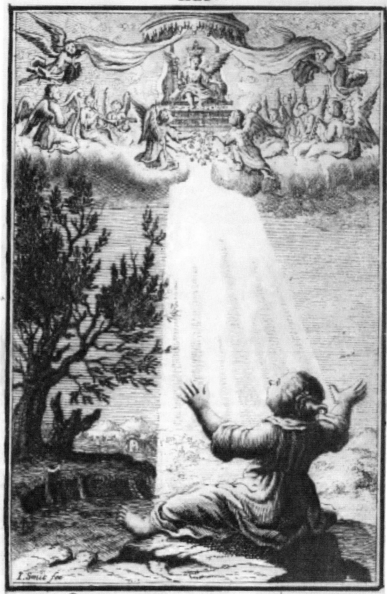

Quam dilecta tabernacula tua, Domine vir
tutum! Concupiscit et deficit anima mea
in atria Domini. Psal. 83.

EMBLEM XLIV

Lord of hosts, your tabernacles are lovely! My soul yearns and burns with desire to be in the house of the Lord.

Your tabernacle, Love, is desirable,
God all powerful, O Lord of virtues!
Simple beauty that is adorable,
You hold my senses suspended.

You take my self away;
I know not what I am:
My love becomes more extreme,
And more that I can express.

Alas, I lost the word;
Speak to me, you, my sovereign Good:
I now apprehend you in your school,
You instruct me in secret in my nothingness.

When I search for you by myself,
I am supported by my own efforts;
But your supreme wisdom
Shows me your marvelous springs.
The Spirit shows me that we must love you,
And that I must moderate my transports,
They are too low for your supreme grandeur.

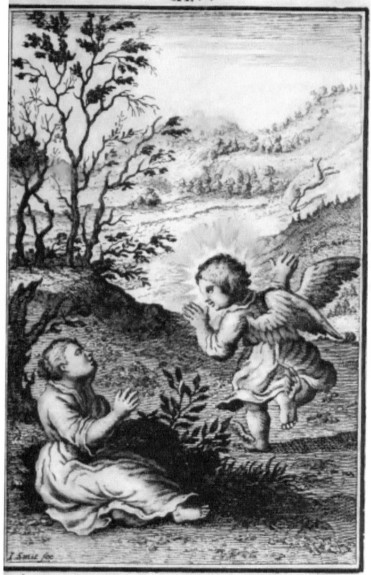

Fuge dilecte mi, et assimilare capreæ, hinnuloq.
cervorum super montes aromatum. Cantic. 8.

f. g

EMBLEM XLV

Make haste, O my Beloved, and be like a deer or a stag upon mountains of spices.

You have taught me a high lesson,
O very charming Doctor, with whom my soul is content!
I do not love my way anymore.
I am in the debt of a perfect Lover.

I wanted you for me, but I now want you for you:
Flee, go, my dear Bridegroom,
Run and make the conquest;
I have no more requests
Except for your interests and for the pure love:
Go, run throughout all the earth,
Make for all a long sojourn
A distant journey to one and the other hemisphere,
Gather one hundred thousand hearts: my satisfied spirit
No longer wishes for me.

That I was weak, alas, believe my pure flame!
With a mixture of purposes,
I loved me and not you;
Can we love the sovereign Lord?

I love you now with a new strength:
And without distraction,
My love is one hundred times stronger;
It is pure, it is simple and without disguise.

O my heavenly Bridegroom, win the victory
Over all hearts in this great universe;
I think only of your glory:
And when I suffer various diverse torments,
My heart, my sad heart, will no longer complain,
You love me without pretense:
There is no longer any separation:
I have found the secret of the whole union.

Be perfect, indivisible, immense,
Fill all without occupying any place,
I, who cry over your absence,
Know that you are GOD.

Conclusion

Conclude that the end of our tender sighs,
Is the end of all we desire.
Who do we desire except you, my adorable Master?
The heavens without you, sweet Author of my being,
Would not satisfy a heart like mine.
You are my only good.
With you sorrows serve to my advantage.
Hell, even hell, if I were near you
Would be a happy portion,
The torments would seem sweet.
Heaven and all its delights
Without you would be torture.

To put this in the day
Let us say that all places where the heart loves you,
Will be near you:
It is no longer torment where your Love reigns.

Make haste peacefully, O my fire,
Spark in strong places:
Causing the sighs of either fear or of zeal,
For the glory of my God.

THE END

Selected Bibliography

Arwaker, EDM. 1690. Translation of Herman Hugo's *Pia Desideria* named *Divine addresses in Three Books*. London: Herny Bonwicke.

Begheyn, Paul. 2009. *Jesuit Books in the Low Countries 1540-1773: A Selection from the Maurits Sabbe Library*. Edited by Paul Begheyn S.J., Bernard Deprez, Rob Faesen S.J., and Leo Kenis. Marits Sabbebibliotheek Faculteit Godgeleerdheid, Peeters, Leuven.

Black, Hester M. 1971. "Introductory Note." In Herman Hugo *Pia Desideria* 1624, UK: Scolar Press.

Catherine of Genoa. 1907. *Life and Doctrine of Saint Catherine of Genoa*. Translated from the Italian. New York: Christian Press Association Publishing Co.

Daly, Peter M. 2008. *Companion to Emblem Studies*. New York: AMS Press, Inc.

Dimler, G. Richard, S.J. 1988. "Edmund Arwaker's Translation of the *Pia Desideria*: The reception of a Continental Jesuit Emblem book in Seventeenth-Century England." *The English Emblem and the Continental Tradition*. Edited by Peter M. Daly. New York: AMS Press.

———. 2008. "The Jesuit Emblem" in *Companion to Emblem Studies*.

———. 2007. *Studies in the Jesuit Emblem*. New York: AMS Press.

Gelderblom, Arie-Jan, Jan L. Dejong, Marc Van Vaeck, editors. 2004. *The Low Countries as a Crossroads of Religious Beliefs*. Brill, Leiden, Boston: Intersections.

Gondal, Marie-Louise. 1989. *Madame Guyon: un noveau visage*. Paris: Beauchesne.

Guiderdoni-Bruslé, Agnès. 2004. "*L'Ame Amante de son Dieu* by Madame Guyon (1717): Pure Love between Antwerp, Paris and Amsterdam, at the crossroads of Orthodoxy and Heterodoxy." in *The Low Countries as a Crossroads of Religious Beliefs*. Edited by Arie-Jan Gelderblom.

Jan L. Dejong, Marc Van Vaeck. Intersections: Brill, Leiden, Boston. pg. 297-318.

Guyon, Jeanne. 1717. *L'Ame Amante de son Dieu*, Cologne: Jean de la Pierre. Emblem Collection of the University of Illinois Archive. http://archive.org/details/lameamantedesond00hugo.

————. 1717. *Ame Amante de son Dieu, representée dans les emblems de Hermannus Hugo sur ses pieux desirs: & dans ceux d'Othon Vaenius sur l'amour divin. Avec des figures nouvelles acompangées de vers qui en font l'aplication aux dispositions les plus essential.* Cologne: Jean de la Pierre.

Hugo, Hermann SJ, 1624. *Pia Desideria Emblamatis Elegiis & affectibus S.S. Patrum illustra.* Anvers.

Ignatius of Loyola. 1964. The Spiritual Exercises of St. Ignatius. Translated by Anthony Mottola. Garden City, NJ: Image Books.

James, Nancy Carol. 2011. *The Complete Madame Guyon.* Massachusetts: Paraclete Press.

————. 1998. *The Apophatic Mysticism of Madame Guyon.* Michigan: UMI Dissertation Services.

————. 2007. *The Pure Love of Madame Guyon.* Lanham, Maryland: University Press of America.

James, Nancy Carol and Sharon D. Voros. 2012. *Bastille Witness: the Prison Autobiography of Madame Guyon (1648-1717).* Lanham, Maryland: University Press of America.

John de Saint-Samson. 1975. *Prayer, aspiration, and contemplation: selections from the writings of John of St. Samson, mystic and charismatic.* Edited and translated by Venard Poslusney. Staten Island, New York: Alba House.

Jeanne of the Nativity. 1899. *The Life of Armelle Nicolas.* Translated from the French by Thomas Taylor Allen. London: H. R. Allenson, Limited.

Lawrence of the Resurrection. 1926. *The Practice of the Presence of God.* Translated by Donald Attwater. London: Burns, Oates and Washbourne.

Poiret, Pierre. 1708. *Bibliotheca mysticorum selecta.* Amsterdam.

Quarles, Francis. 1635. *Emblems.* Delmar, NY: Scholars Facsimiles & Reprints, 1991.

Ricoeur, Paul. 1967. *The Symbolism of Evil.* New York: Harper & Row.

Russell, Daniel. 1995. *Emblematic Structures in Renaissance French Culture.* Toronto: University of Toronto Press.

Teresa of Avila. 1991. *The life of Teresa of Jesus: the autobiography of Teresa of Avila.* Edited and translated by E. Allison Peers from the critical edition of Silverio de Santa Teresa. New York: Doubleday.

Veen, Otto van. 1615. *Amoris Divini Emblemata.* Anvers.

Ward, Patricia. 2009. *Experimental Theology in America: Madame Guyon, Fénelon and Their Readers.* Waco, Texas: Baylor University Press

Index